D1256113

MONET'S WATER LILIES

MONET'S WATER LILIES:

The *Agapanthus* Triptych

SIMON KELLY

with Mary Schafer and Johanna Bernstein

THE SAINT LOUIS ART MUSEUM

with The Nelson-Atkins Museum of Art and The Cleveland Museum of Art

Published in connection with the exhibition "Monet's Water Lilies," held at The Nelson-Atkins Museum of Art (April 9–August 7, 2011), the Saint Louis Art Museum (October 2, 2011–January 22, 2012), and The Cleveland Museum of Art (2015).

© 2011 Saint Louis Art Museum

All rights reserved. No part of this publication may be reproduced or transmitted in any form or by any means, electronic or mechanical, including photocopy, recording, or any information storage or retrieval system, without permission in writing from the publisher.

Second printing

Published by the Saint Louis Art Museum in association with the University of Washington Press, Seattle and London.

Saint Louis Art Museum
One Fine Arts Drive
St. Louis, MO 63110-1380
www.slam.org

Distributed by
University of Washington Press
P.O. Box 50096
Seattle, WA 98145-5096
www.washington.edu/uwpress

Edited by Susan F. Rossen
Designed and produced by Glue + Paper Workshop, Chicago
Color separations by Professional Graphics, Inc., Rockford, Illinois
Printed and bound by The Printing Source, Inc., St. Louis

ISBN 978-0-89178-095-3

Library of Congress Cataloging-in-Publication Data

Kelly, Simon, 1969–
Monet's Water lilies : the Agapanthus triptych/Simon Kelly, with Mary Schafer and Johanna Bernstein.

 p. cm.

 Published in connection with an exhibition held at the Nelson-Atkins Museum of Art, Apr. 9–Aug. 7, 2011, the Saint Louis Art Museum, Oct. 2, 2011–Jan. 22, 2012, and the Cleveland Museum of Art, 2015.

Includes bibliographical references.

 1. Monet, Claude, 1840–1926. Agapanthus triptych—Exhibitions. 2. Monet, Claude, 1840–1926—Criticism and interpretation. 3. Water lilies in art—Exhibitions. I. Monet, Claude, 1840–1926. II. Schafer, Mary, 1975– III. Bernstein, Johanna, 1965– IV. Cleveland Museum of Art. V. Nelson-Atkins Museum of Art. VI. St. Louis Art Museum. VII. Title. VIII. Title: Agapanthus triptych.

ND553.M7A64 2011

759.4—dc22 2011006076

Cover: Claude Monet. *Agapanthus*, detail of figs. 1 and 29 (the detail changes depending on the version of this book intended for each of the three venues, featuring whichever *Agapanthus* panel is in that venue's collection).

Pages 1 and 11: Detail of figs. 1 and 29, left panel (The Cleveland Museum of Art).

Pages 3, 8, and 53: Detail of figs. 1 and 29, right panel (The Nelson-Atkins Museum of Art).

Pages 7 and 60: Detail of figs. 1 and 29, center panel (Saint Louis Art Museum).

Pages 63 and 64: Simon Kelly. *Claude Monet's Water-lily Pond, Giverny*, 2010.

Inside back cover: Fold-out of *Agapanthus*, see figs. 1 and 29.

All collection photography for the Saint Louis Art Museum by Jean Paul Torno.

CONTENTS

Monet's Water Lilies reunites the three panels of Claude Monet's *Agapanthus* triptych, created between about 1915 and 1926. The Saint Louis Art Museum, Nelson-Atkins Museum of Art, and Cleveland Museum of Art each own one panel of this important work, and this collaboration offers the first opportunity in over a generation to see this painting as the artist originally intended.

Claude Monet was without doubt the most important of the Impressionist painters, and his large-scale water-lily paintings represent the culminating achievement of his long career. There are only two triptychs by the artist in the United States: *Clouds*, at New York's Museum of Modern Art, and *Agapanthus*. The exhibition that occasioned this book explores the latter's complex history, examining Monet's extensive revisions and original plans for its installation, as well as new archival and technical research.

Monet's late *Water Lilies* were largely neglected in the decades after his death but were rediscovered in the 1950s, as the painters of the American Abstract Expressionist movement found in them an important precedent for their own output. Our three museums were among the first American institutions to purchase these works; Saint Louis acquired its panel in 1956, followed by the Nelson-Atkins in 1957 and Cleveland in 1960.

Thanks are due to Simon Kelly, Curator of Modern and Contemporary Art at the Saint Louis Art Museum, who curated the show in Kansas City and Saint Louis and wrote the principal essay for the catalogue. We are grateful to conservators Mary Schafer and Johanna Bernstein for their contribution. We also acknowledge Marc F. Wilson, former director of the Nelson-Atkins Museum of Art, for initiating the project; and Timothy Rub, former director, and Deborah Gribbon, former interim director, at the Cleveland Museum of Art, for their enthusiasm.

We would like to thank the Federal Council on the Arts and the Humanities for the grant of United States Government indemnity, without which this undertaking would not have been possible. Conservation analysis was also supported by the Andrew W. Mellon Foundation. Emerson provided support for the exhibition and catalogue. We are grateful for support for the Kansas City presentation from the Hartley Family Foundation, Fred J. Logan Jr. in honor of Carol H. Logan's service as a Nelson-Atkins docent, Frank L. Victor, the Campbell-Calvin Fund, and the Elizabeth C. Bonner Charitable Trust for exhibitions. We are pleased that *Monet's Water Lilies* will offer new insight into this remarkable work of art and its importance in our broader understanding of Monet's career.

Brent R. Benjamin, *The Saint Louis Art Museum*
Julián Zugazagoitia, *The Nelson-Atkins Museum of Art*
David Franklin, *The Cleveland Museum of Art*

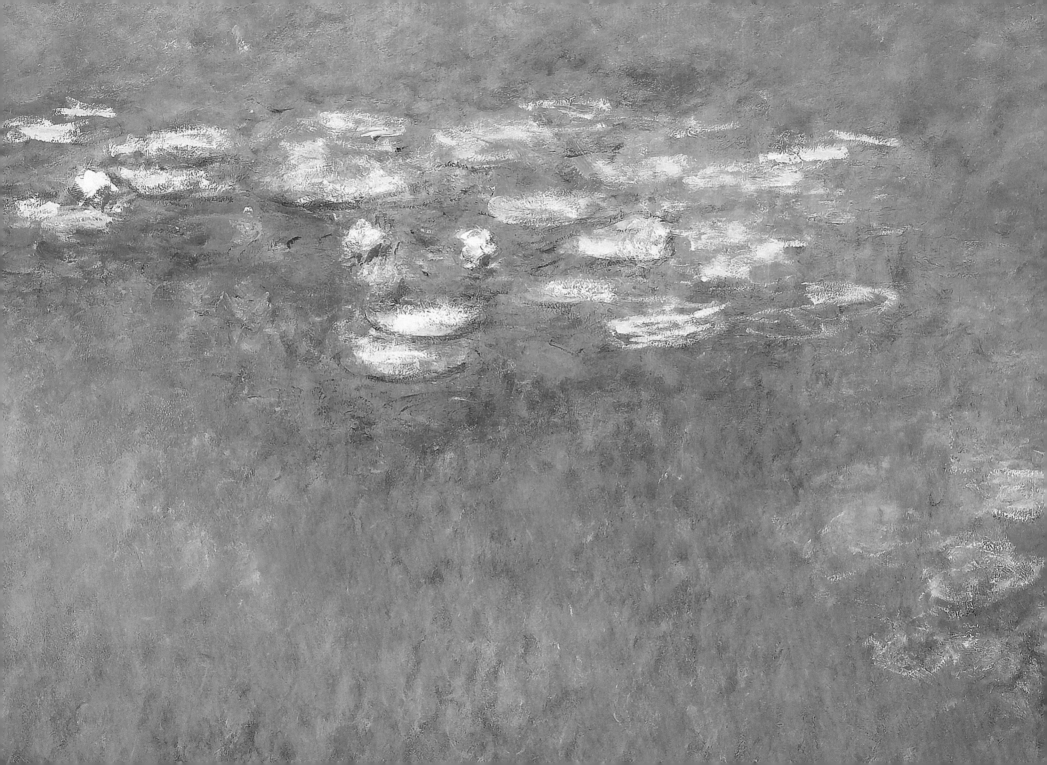

ACKNOWLEDGMENTS

MANY INDIVIDUALS HAVE ASSISTED in the development of this catalogue and the exhibition it accompanies. At the Saint Louis Art Museum, I should like to thank first and foremost Director Brent Benjamin, who supported the project from the outset. I would also like to acknowledge Linda Thomas, Assistant Director for Exhibitions and Collections, for her work on the catalogue. This project originated when I was Associate Curator of European Painting and Sculpture at the Nelson-Atkins Museum of Art, where the exhibition opens. There I should like to thank Julián Zugazagoitia, Menefee D. and Mary Louise Blackwell Director and CEO, along with his predecessor, Marc Wilson. I am grateful as well to Ian Kennedy, Louis and Adelaide Ward Curator of European Painting and Sculpture, and Cindy Cart, Curator of Exhibitions Management. At the exhibition's third venue, the Cleveland Museum of Art, thanks are due to William Robinson, Curator of Modern European Art, and Heidi Strean, Director of Exhibitions.

The collaboration with my conservator colleagues Mary Schafer, Associate Painting Conservator, the Nelson-Atkins Museum of Art, and Johanna Bernstein, Project Scientist, Institute for Advanced Materials, Devices and Nanotechnology, Rutgers—The State University of New Jersey, has been invaluable. Mary Schafer and I would like to thank those who assisted in the x-radiography of the *Agapanthus* panels at the three museums: Paul Haner, Director of Conservation and Paintings Conservator, the Saint Louis Art Museum; Scott Heffley, Senior Paintings Conservator, and Joe Rogers, Objects Conservation Associate, the Nelson-Atkins Museum of Art; and Dean Yoder, Conservator of Paintings, and Marcia Steele, Chief Conservator, at the Cleveland Museum of Art, as well as the Imaging and Preparation Departments at the three museums. Johanna Bernstein would like to thank Lauren A. Klein, Department of Chemistry and Chemical Biology, Rutgers, for help with elemental analysis, and the Winterthur Museum and Country Estate for the use of the microscope in its Painting Conservation Laboratory.

I am grateful to John House, Professor Emeritus at the Courtauld Institute of Art, London, who read my manuscript and made several helpful comments. I appreciate the assistance of Robert Gordon, who provided valuable photographic material. Thanks are due to two colleagues in Paris: Sylvie Patry, Curator at the Musée d'Orsay, for her interest in the project, and Véronique Mattiussi, Curator at the Musée Rodin. Finally, I should like to thank Susan F. Rossen for her thoughtful editing of the catalogue; Joan Sommers and Amanda Freymann of Glue + Paper Workshop, Chicago, for designing this attractive book; and Pat Soden, Director of the University of Washington Press, for his support of the publication.

SIMON KELLY
Curator of Modern and Contemporary Art
The Saint Louis Art Museum

SIMON KELLY

Monet's Water Lilies: The *Agapanthus* Triptych

FOR THREE BRIEF WEEKS in the fall of 1956, an exhibition of Claude Monet's water-lily paintings captivated New York audiences. The show at Knoedler & Company was the first in the United States to focus on these late works, and its centerpiece was a richly colorful triptych that, as *New York Herald-Tribune* critic Emily Genauer noted, filled the gallery "with the effulgent glow of violet, pink, blue and yellow stained glass."[1] This three-panel painting, which had remained in Monet's studio for almost three decades after his death, was revealed for the first time to an American public (fig. 1). Soon after the exhibition, the triptych was divided up and sold to three midwestern museums—the Saint Louis Art Museum; the Nelson-Atkins Museum of Art in Kansas City, Missouri; and the Cleveland Museum of Art. While these acquisitions assured that the work would remain in the public domain, they nonetheless departed from Monet's intention that the panels should stay together as a group, with each complementing the other.[2] Perhaps because it has been

split up, the triptych has not received as much attention as others by Monet. Yet it is of fundamental importance. At one point, the artist himself described it as one of his "four best" water-lily triptychs.[3] He obsessively revised the work over several years and, as a result, it has a fascinating and revealing history of extensive artistic changes. The exhibition that occasioned this book offered an opportunity to reunite the three sections of the triptych, using Monet's original title, *Agapanthus*, named for the plant that once featured in the left panel.

The increasing fascination with Monet's late water-lily paintings in recent years has resulted in a number of exhibitions, as well as extremely high commercial prices.[4] These works have also prompted a diverse range of interpretations.[5] They have been seen as anticipating American Abstract Expressionism of the 1950s, continuing a reading first fully articulated by the critic Clement Greenberg.[6] They have been examined too within the context of Monet's fascination with his garden—and his own role as a garden designer—at Giverny.[7] Another

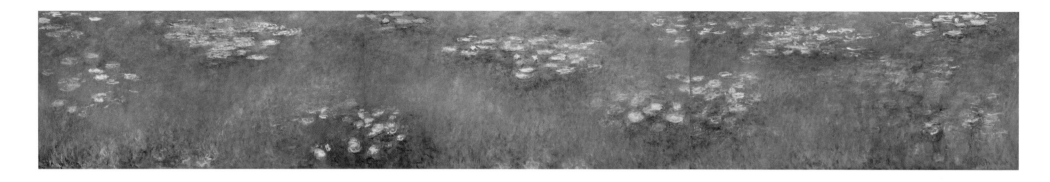

FIG. 1

Claude Monet (French, 1840–1926). *Agapanthus*, c. 1915–1926. Oil on canvas; 79 ¼ (max.) x 502 ⅞ in. (201.3 [max.] x 1,277.3 cm).

(LEFT PANEL)

Water Lilies, Agapanthus, c. 1915–1926. Oil on canvas; 79 ¼ x 167 ⅝ in. (201.30 x 425.8 cm). The Cleveland Museum of Art, John L. Severance Fund, 1960.81.

(CENTER PANEL)

Water Lilies, c. 1915–1926. Oil on canvas; 78 ¾ x 167 ¾ in. (200 x 426 cm). Saint Louis Art Museum, The Steinberg Charitable Fund, 134:1956.

(RIGHT PANEL)

Water Lilies, c. 1915–1926. Oil on canvas; 78 ¾ x 167 ½ in. (200 x 425.5 cm). The Nelson-Atkins Museum of Art, Kansas City, Missouri, Purchase: William Rockhill Nelson Trust, 57-26.

All artists whose work is illustrated in this book are French, unless noted otherwise.

reading has focused on the impact on Monet's art of his deteriorating eyesight as a result of cataracts.[8] The artist's emphasis on gazing into his pool has been seen too in psychoanalytical terms, as an extension of the Narcissus myth.[9]

Our project derives its uniqueness from a close focus on the complex history of a single triptych, *Agapanthus*. Drawing on archival research and scientific conservation analysis, we explore, for the first time in detail, the genesis and evolution of this work, considering it within the context of Monet's preliminary studies as well as establishing its centrality to the large-scale decorative ensembles he conceived, such as that at the Musée de l'Orangerie, Paris. As we shall see, this close focus leads to a much broader understanding of Monet's late work and his identity as an artist.

Monet's late, large-scale water-lily compositions, described by the artist as his "Grandes Décorations," are often seen as the culminating moment not only of his career but of the Impressionist project

as a whole. Forty-one panels exist.[10] Twenty-two of these are now permanently installed in the Musée de l'Orangerie, a space that the Surrealist painter André Masson described as the "Sistine Chapel of Impressionism."[11] Others are scattered around Europe (particularly Switzerland) and the United States. *Agapanthus* and *Clouds* (The Museum of Modern Art, New York) are the only triptychs in the U.S. Monet worked on *Agapanthus*, which is among his most subtly colorful decorative ensembles, over more than ten years, from about 1915 to his death in 1926. Together, its three fourteen-foot panels total forty-two feet in width. *Agapanthus* is divided broadly into two horizontal bands, with the triptych's upper third dominated by blue and violet tonalities and the lower two-thirds by yellow-green. The complex surfaces defy easy legibility, but the top area suggests the reflection of sky, while the lower section references the depths below, suggesting the swaying, grassy fronds and the yellow bottom of the shallow pond. The dominant tones mask a deeply nuanced range of colors, from lavender to pink to aquamarine to crimson red, all of which invest the painting with an inner luminosity. Indeed, Arsène Alexandre, one of Monet's first biographers, noted that, surrounded by the water-lily triptychs, "we are in the domain of pure color."[12] Recent technical analysis has documented the nature of Monet's palette in this painting with a new specificity, indicating his use of such pigments as lead white, cobalt violet, chromium oxide green, cadmium yellow, and zinc yellow. All of these are consistent with ones that have been found on other paintings by Monet of the same period.[13] The triptych is animated by several rafts of water lilies whose blooms are more distinctly articulated in the middle section than in the flanking ones. In effect, the blossoms in the composition's central portion constitute the triptych's most dramatic color accents. This was no doubt quite intentional on the artist's part, for it reinforces the middle panel as *Agapanthus*'s main focus of attention.

As with so many of Monet's water-lily paintings, the triptych is compositionally distinguished by the absence of a horizon line, prohibiting a sense of spatial recession and increasing the impression of flatness. For many critics, this aspect represented Monet's greatest radicalism. Roger Marx for example saw the eradication of any reference to spatial markers such as a riverbank as definitively fracturing all links to previous landscape schools.[14] Greenberg would note that, in these late works, everything became "foreground."[15] *Agapanthus* also displays the animated and gestural handling characteristic of Monet's late panels, as he refreshed his surfaces using the large, broad brushes that he favored. The artist applied pigment in rapid, calligraphic brush marks, outlining the lily pads sometimes in red, sometimes in black, and sometimes in yellow, and employing slashing, crisscrossed strokes to suggest the shimmering, evanescent play of light across water. For all his revisions, Monet was able to retain a freshness and vigor in his touch.

Monet at Giverny

Before looking at the *Agapanthus* triptych in detail, it is useful to have some background on the place that inspired the work, namely the water garden at Monet's property in the Norman village of Giverny. Closely associated with his name, Giverny attracts hundreds of thousands of visitors every year. Monet's water-lily triptychs indeed represent the culmination of his attachment to Giverny, where he moved in 1883 and spent the rest of his life. In 1893 he diverted water from the nearby Epte River in order to create the pond that would inspire him greatly. He built the water garden, he wrote laconically, for "the pleasure of the eyes and also with the aim of motifs to paint."[16] In 1895 Monet added a Japanese footbridge and in 1901 bought additional land in order to triple the size of the pond. In one

FIG. 2

Jacques-Ernest Bulloz
(1858–1942). Claude Monet
next to his water-lily pond
at Giverny, summer 1905.
Gelatin silver print; 6 ¹⁵/₁₆ x
5 ¹/₁₆ in. (17.7 x 12.8 cm).

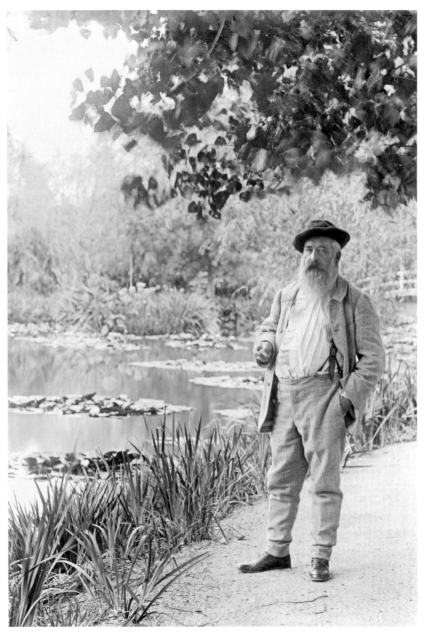

photograph (fig. 2), he stands alongside the pond dressed in the dandyish type of outfit he favored. A small, compact man measuring five feet five inches in height, he wears here a tweed suit specially made by the up-market British tailors Old England and one of the frilly shirts that were his sartorial trademark. Monet's garden was as manicured and neat as he was. He hired six gardeners, led by Félix Breuil, to oversee the upkeep of his garden enterprise. One was assigned specifically to care for the water-lily pond; among his duties were removing

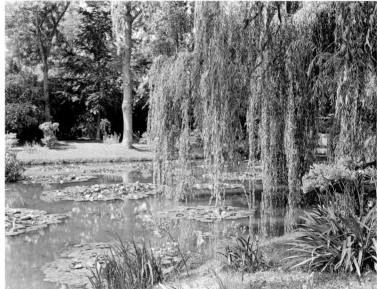

FIG. 3

View of the pond at Giverny
with water lilies, willows, and
agapanthus, c. 1933.

dead flowers from the water and dusting the lily pads every morning. Another photograph shows the carefully arranged water-lily pads, as well as the willows and agapanthus plants that grew alongside the pond (fig. 3).

For the last three decades of his life, Monet focused almost exclusively on his water garden, particularly the water lilies. In general he traveled little (a trip to Venice in 1908 was a rare exception) and developed a near-obsessive fascination with the relatively limited range of motifs in his garden, producing approximately 250 surviving views of the pond. (The artist destroyed several others in frustration, ripping them from their stretchers and burning them in his legendary bonfires.) Monet first used his pond as a motif in 1895 and was inspired soon after to produce a series of Japanese-bridge paintings, exhibited to acclaim in 1900 (see fig. 4). Subsequently, he focused more intently on the pond's surface, removing references to the surrounding banks and creating works he described as his "water landscapes." Monet here used his established practice of serial repetition, examining the transformation of a particular subject by varying light effects (see figs. 5–6). Serial repetition is arguably Monet's most important artistic legacy, offering a conceptual model that had greater and more lasting resonance than even the formal innovations of his work on younger artists such as the Abstract Expressionists. It became central to the practice of artists from Josef Albers to Andy Warhol and beyond.[17]

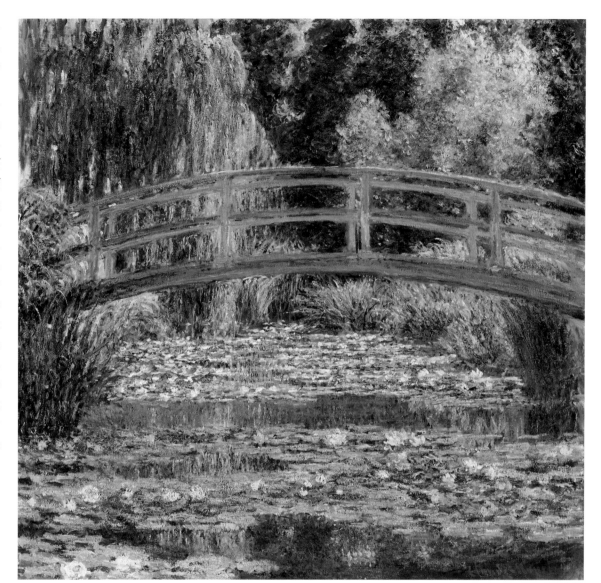

15

FIG. 4

Claude Monet. *The Japanese Footbridge and the Water-Lily Pool, Giverny*, 1899. Oil on canvas; 35 ⅛ x 36 ¾ in. (89.2 x 93.3 cm). The Philadelphia Museum of Art, Mr. and Mrs. Carroll S. Tyson, Jr. Collection, 1963.

FIG. 5 (LEFT)

Claude Monet. *Pond with Water Lilies*, 1907. Oil on canvas; 42 x 29 in. (106.7 x 73.7 cm). The Israel Museum, Jerusalem, Israel.

FIG. 6 (RIGHT)

Claude Monet. *Water Lilies*, 1907. Oil on canvas; 39 x 28 ½ in. (99.1 x 72.4 cm). Musée Marmottan Monet, Paris.

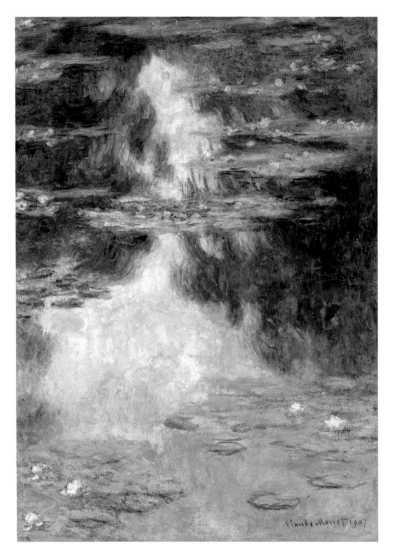

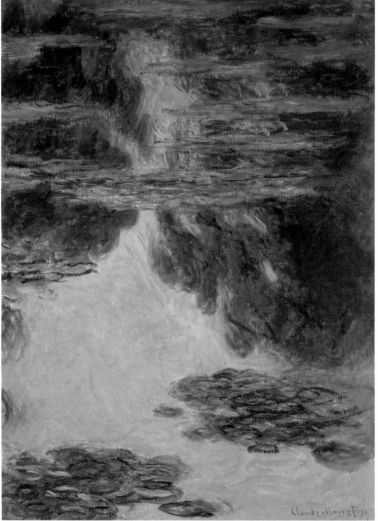

Why was Monet so fascinated with water lilies? Certainly, the plant's mysterious and suggestive character intrigued Symbolist artists and writers. However, the mythological narrative alluded to by the floating nymph in *Water Lilies* (fig. 7) by the Symbolist painter Gaston Bussière is far from Monet's focus on the water lilies themselves. Monet was aware of the prose poem *The White Water Lily* (1885) by his friend Stéphane Mallarmé, in which the protaganist picks a water lily that evokes the image of an unseen woman he desires. He probably also knew Marcel Proust's descriptions of water lilies on the Vivonne River in *In Search of Lost Time (À la recherche du temps perdu*; 1909–22). Here Proust focused on the lilies' formal beauty in a water garden alongside the river, undoubtedly inspired by Monet's garden, which the author had visited in 1909. Proust described a red lily, for example, as "blushing like a strawberry," while blue lilies reminded him of "garden pansies that had settled here like butterflies and were fluttering their blue and burnished wings." He emphasized too the importance of the reflections of sun and sky in "this watery garden—this celestial garden," in which the lilies seemed to "blossom in the sky itself."[18] Yet both Mallarmé and Proust wrote about the flowers only occasionally, in contrast to Monet's intense preoccupation with them. Perhaps the closest comparison to Monet's absorption with the water lily can be found in the decorative arts, as in Émile Gallé's glass objects, whose surfaces are often decorated with the elegant silhouettes of the motif.[19] In 1918 Monet provided perhaps the best insight to his motivation:

> I have painted these water lilies a great deal, modifying my viewpoint each time. . . . The effect varies constantly, not only from one season to the next, but from one minute to the next, since the water-flowers themselves are far from being the whole scene; really, they are just the accompaniment. The essence of

the motif is the mirror of water, whose appearance alters at every moment, thanks to the patches of sky that are reflected in it, and give it its light and movement. . . . So many factors, undetectable to the uninitiated eye, transform the coloring and distort the planes of the water.[20]

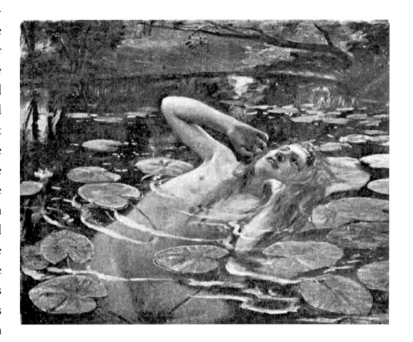

FIG. 7

Reproduction after Gaston Bussière (1862–1928). *Water Lilies*, 1901. Oil on canvas. Whereabouts unknown. From: *Catalogue illustré du Salon* (Paris: Société des Artistes français, 1901), [p. 55].

This statement indicates that Monet was in fact most interested by the water surrounding the lilies rather than by the flowers themselves. His fascination with water and its reflections dates to his upbringing on the Normandy coast and the marines that first earned him recognition in the mid-1860s. Throughout his career, Monet specialized in river and sea views. Édouard Manet in fact famously described him as the "Raphael of water."[21] Thus the water-lily pond was the culmination of a lifelong interest. At Giverny he was able to concentrate on the subject, studying the pond—its surface and its depths—without distraction and often for hours on end. Monet admitted that these "landscapes of water and reflections" had become an "obsession."[22]

Monet may have been absorbed by an intense phenomenological study of water surfaces and the manner in which light transforms them, but his interest in water lilies themselves was also profound. He thought of his pond as a kind of palette and, as already noted, treated lily blossoms as color accents.[23] He subscribed to several horticultural journals and developed a close association with a famed grower, Joseph Bory Latour-Marliac, who created exotically colored hybrids using species from Africa and Asia, in contrast to the established yellow and white indigenous breeds. Latour-Marliac first gained fame for a display of his water lilies in a specially designed stream at the 1889 Exposition Universelle, Paris, which Monet would have seen. In the years to come, the artist ordered at least seven different kinds of exotic breeds from Latour-Marliac and even visited his nursery in Bordeaux in 1904. He also ordered several species of lotus, a type of water lily that figures in Far Eastern religions and art, but they failed to grow in his garden. We can only speculate on the types represented in the *Agapanthus* triptych, but the intense red blooms may be identified as the *William Falconer* species that Monet acquired in 1904.[24]

Monet's Japanese-bridge and water-landscape views are mid-sized easel paintings. But the artist nurtured plans to work on a larger scale, reflecting the kind of exceptional ambition that he had shown even as a young artist. Around 1914 he dramatically increased the size of his water-lily panels in order to create his "Grandes Décorations." Monet was well aware of the challenges involved in such monumentality; his first reference to this new project, in January 1915, reveals a mixture of trepidation and excitement: "I'm pursuing my idea of a *Grande Décoration*. It's really an enormous task that I've undertaken, above all at my age, but I am not unhopeful of achieving it if I stay healthy. . . . It's a question of this project that I have had for a long time now: water, water lilies, plants, but on a very large surface."[25] Monet's ambition here is worthy of note, even more so since he was now seventy-four. He soon realized the need for a new space to house the enormous panels, and in the summer of 1915 began to build another studio in his garden at Giverny. Soon completed, it measured twenty-three meters in length, twelve in width, and fifteen in height and featured blind walls with natural light filtered through a translucent shade from two rows of windows in the roof (fig. 8). In this enormous space—today the store in the Monet museum at Giverny—Monet painted *Agapanthus* and his other late triptychs.

The Studies

Monet's studio work on his "Grandes Décorations" was underpinned by studies he executed outdoors in front of his pond. His *plein-air* practice is evident in Sacha Guitry's 1915 documentary *Ceux de chez nous* (Those of Our Land), a film produced during World War I as a patriotic celebration of France's cultural heroes. For a brief two-and-one-half minutes, Monet is seen walking around his garden and painting beside his pond in a pristine white suit and with the habitual cigarette hanging from his mouth (see figs. 9–10). Umbrellas diffuse the light around him, while a large-brimmed hat protects his

18

FIG. 8 (OPPOSITE)
Henri Manuel (1885–1957).
Monet in his large studio at
Giverny, c. 1923. Archives
Durand-Ruel, Paris.

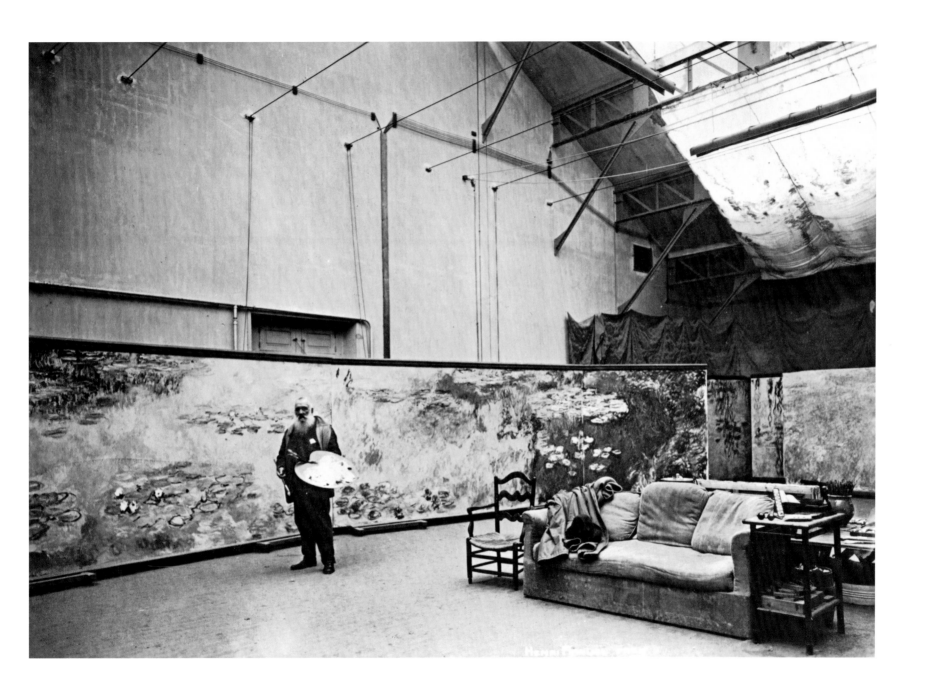

FIGS. 9–10
Sacha Guitry (1885–1956). Monet painting at Giverny, 1915. Film stills from *Ceux de chez nous*.

eyes from the sun's rays. The painting in the film is two meters (over six and one-half feet) high, demonstrating the significant size of these outdoor studies.[26] In the years 1914–17, Monet executed as many as seventy such works, which he had taken back to his studio for use as *aides-mémoire*. Some of these, of course, may also have been produced in the studio as more conventional compositional sketches.

Monet's practice of translating these studies into his large-scale triptychs can be understood by examining the history of *Agapanthus*, beginning with an early stage of creation. Fortunately, archival photographs survive of the work in progress; they reveal a painting very different from the final one. A November 1917 photograph of Monet's studio shows the left and part of the central panel and clearly reveals the presence in the composition of agapanthus that gave the triptych its name (fig. 11). Native to South Africa and known also as "African

Lily" or "Lily of the Nile," it is characterized by funnel-shaped flowers carried on leafless stems and in a range of colors including white, lilac, and blue (see fig. 14). Monet had decorated both sides of his pond with several of these elegant plants. A second 1917 photograph (fig. 12) focuses on the central panel, then in a very early stage and quite unlike what we see today.

Even more valuable than the 1917 photographs is one of the triptych taken in February 1921 for a book on Monet published by the dealers Bernheim-Jeune (fig. 13).[27] This shows the composition in a more advanced state, with two agapanthus plants on a riverbank at the far left of the left panel and several clumps of water lilies, including a large group at the lower-right center of the right panel. The agapanthus act as a repoussoir, providing a spatial marker against the open expanse of water behind, while the articulation of the riverbank

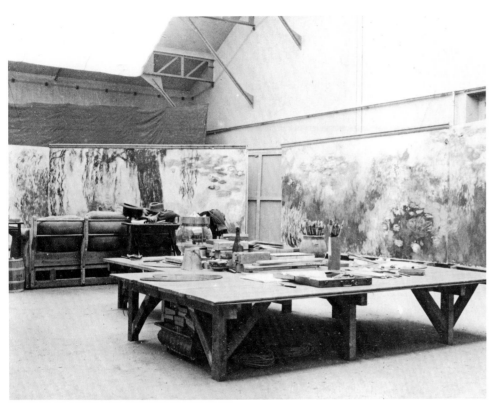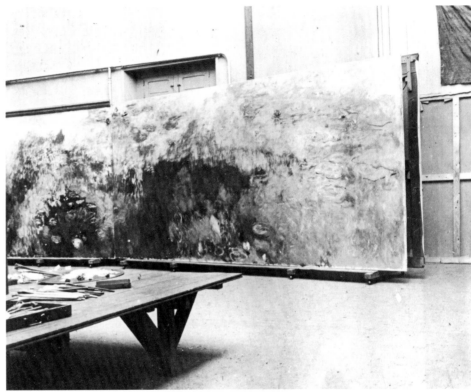

FIGS. 11–12

Monet's large studio at Giverny, November 1917. The left and part of the center panel of *Agapanthus* at an early stage can be seen at the right of fig. 11 (LEFT). Fig. 12 (RIGHT) features the center panel, also early in its development. Archives Durand-Ruel, Paris.

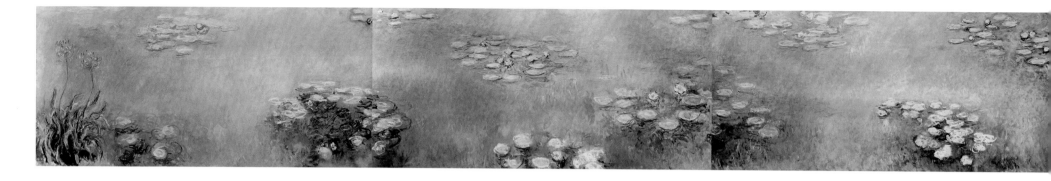

FIG. 13
André Marty (1886–1956).
Agapanthus triptych,
February 14/16, 1921.

FIG. 14
Agapanthus.

also grounds the viewer in the space. Moreover, the water lilies are arranged in far more discrete and defined groupings than would later be the case.

This photograph allows us to relate the triptych in detail to three studies, each the same height as the final panels. The very existence of these studies is testament to Monet's meticulous preparatory methods. In one (fig. 15), which served as the model for the left panel, the agapanthus rise from a twisting mass of leaves on the riverbank.[28] Behind them Monet rendered the surface of the pond with the bands of yellow-green and blue that he would retain in the final panels. The presence of so much unpainted canvas—as for example around the painting's edges and in the lily pads themselves—indicates that the artist intended this work strictly for his own use rather than for public viewing. Comparison of the study with what we see in the 1921 photograph reveals that Monet transferred the configuration of aga-panthus plants almost exactly onto his triptych panel. As Paul Hayes Tucker noted, the study served as a "veritable cartoon," with the softly curving stems of the agapanthus closely echoed in the panel.[29] There is no underdrawing here or anywhere in the triptych. Monet must have transposed his motif freehand.

A second study (fig. 16) provided the basis for the lower-right section of the left panel and the extreme left section of the central one. That this study straddles two panels is of interest in itself, highlighting the degree to which Monet saw the triptych as a single painting rather than as a grouping of separate components. Here we can clearly see the twisting, reddened stems of water lilies ascending to the surface amid a dense mass of submerged green vegetation. These elements create a sense of depth, as do the tufts of green foliage that, as in the left panel, reference the riverbank. Monet probably executed this study standing close to the pond's edge, where he could look down into the water just below his feet.

A third study (fig. 17) was crucial for the right side of the right panel. This composition in fact appears in front of the triptych in a photograph taken in November 1916 (fig. 18). Here the artist stands alongside his old friend and supporter Georges Clemenceau, who fig-ured prominently in encouraging the artist's "Grandes Décorations." In this intensely colorful painting, Monet divided the canvas into three zones: crimson red at the bottom left, yellow-green in the center, and blue at the top. In the red area, Monet painted the swirling stems of the lilies as they rise from the bottom of the pond, again suggesting

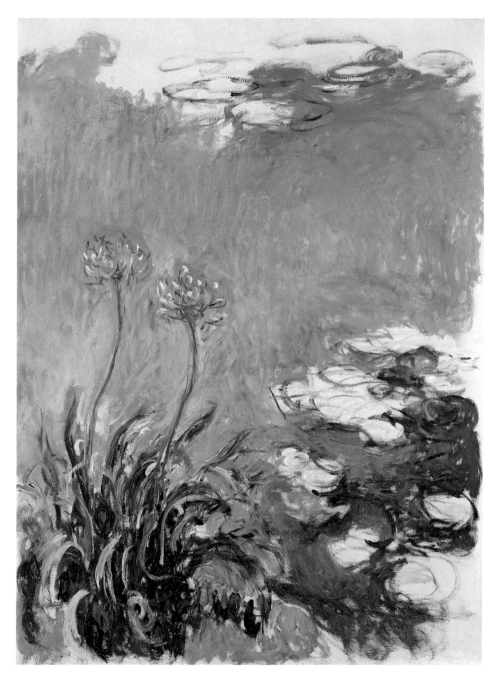

FIG. 15

Claude Monet. *The Agapanthus*,
1914–17. Oil on canvas; 78 ¾ x
59 ¹⁄₁₆ in. (200 x 150 cm). Musée
Marmottan Monet, Paris.
Its relationship to the left panel
of *Agapanthus* (see fig. 13) is
indicated below.

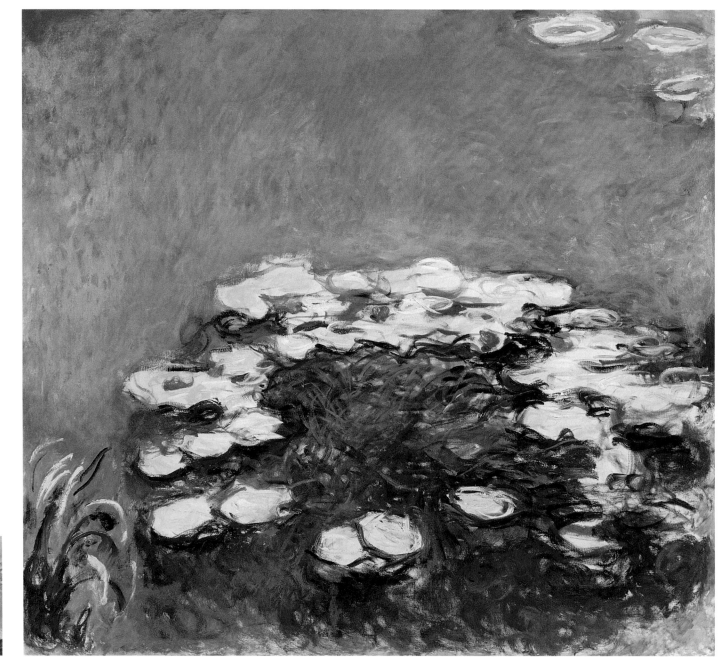

FIG. 16

Claude Monet. *Water Lilies*,
c. 1914–17. Oil on canvas;
70 ⅞ x 78 ¾ in. (180 x 200 cm).
Private collection. Its relation-
ship to the left and center panels
of *Agapanthus* (see fig. 13) is
indicated below.

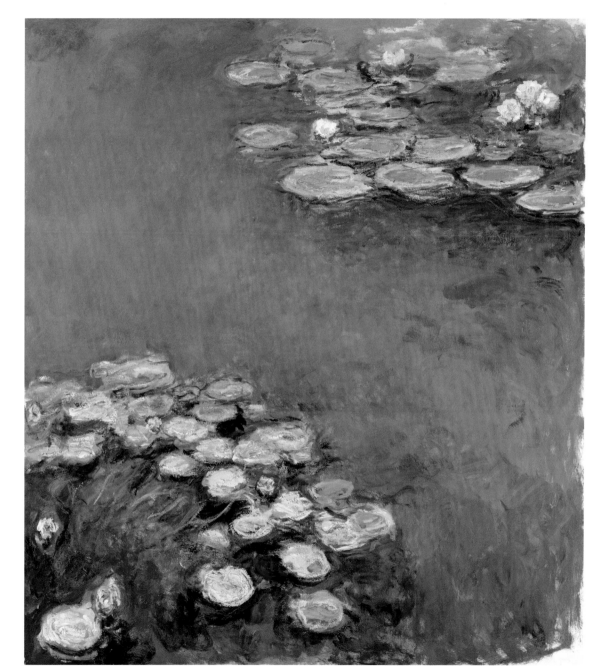

FIG. 17

Claude Monet. *Water Lilies,
Harmony in Blue*, 1914–17.
Oil on canvas; 78 ¾ x 78 ¾ in.
(200 x 200 cm). Musée
Marmottan Monet, Paris.
Its relationship to the right panel
of *Agapanthus* (see fig. 13) is
indicated below.

FIG. 18

Claude Monet and Georges
Clemenceau in the large studio
at Giverny, c. 1920 (possibly
1916). *Water Lilies, Harmony
in Blue* (fig. 17) can be seen
at the right.

depth. He included ten blooms: five pink-red ones in the lower water-lily cluster; and three yellow, one red, and one white in the upper group. The 1921 photograph reveals the degree to which the artist followed the study's configuration of lily pads and blooms in composing the final panel. This has been confirmed by a recent x-radiograph highlighting the presence of a raft of water lilies at the panel's base (see Schafer and Bernstein, fig. 10). Black-and-white photographs and x-radiographs do not, however, reveal the extent to which Monet may have transferred the colors of his study to the triptych panel. The study's crimson-red area is perhaps the most intriguing, since this color is no longer visible in the final work. Recently removed samples of paint and ground (see Schafer and Bernstein, fig. 11) demonstrate the presence of crimson red in the final panel, proving that originally Monet remained faithful not only to the configuration but also to the palette of this study. As we shall see, he would later paint over the bright red, developing a more nuanced range of pastel hues. Indeed,

paint cross-sections indicate the complexity of Monet's revisions, confirming the presence of as many as eight layers as he developed his surfaces. The coloristic contrast between the study and the panel as it appears today is indeed striking. Intense hues were replaced by more muted tones. Precision in the rendering of lily-pad forms also gave way to far more abstract effects.

Monet and World War I: "This Terrible War"[30]

Monet produced his water-lily images against the backdrop of World War I. The tranquility of his paintings betrays none of the horror and turmoil of the conflict, of which the artist was very much aware. Troop trains passed regularly along the rail line that cut through his garden; from his studio, he could probably even hear the guns at the front. The tenacious leadership of his close friend Clemenceau, the nation's prime minister, known by the epithet "The Tiger," spearheaded the drive to victory. Perhaps most significantly, both Monet's son Michel and stepson Jean-Pierre Hoschedé fought in the French army. Michel enlisted as a volunteer and was first deployed in April 1915, while in the summer of 1914 Jean-Pierre was assigned to the transport corps. Monet's correspondence at the time frequently expresses deep concern for their welfare. On September 11, 1916, for example, he wrote that Michel had survived "three terrible weeks" of fighting at Verdun, arguably the most bloody battle of the entire war and the site of more than two hundred fifty thousand deaths and half a million wounded (see fig. 19).[31]

Given this historical context, Monet's practice, on the one hand, can seem a self-absorbed retreat into a private world of artistic experiment. In fact he seems to have felt some guilt about his formal experiments in a time of war, telling his close friend Gustave Geffroy at the end of 1914, "I should be a bit ashamed to think about little

investigations into forms and colors while so many people suffer and die for us."[32] But on the other hand, it is possible to see Monet's project in a more positive light, for it involved producing works focused on the revivifying power of nature in the face of destruction and barbarism. Far too old to fight, the deeply patriotic Monet felt that he could best contribute to the national cause through his painting. Arsène Alexandre imagined his thoughts: "There are Frenchmen who fight; I can only paint, I have to do what I can do."[33] During the terrible ten-month period of the battle of Verdun—from February to December 1916—Monet found solace in his intense study. Indeed, the year 1916 was a particularly productive one. On March 2, 1916, he wrote from Giverny, "I live here in solitude . . . happily for me I have work which is, in sum, the best means of forgetting a little. Let's hope for the end of this war and victory."[34] On August 26, he stated,

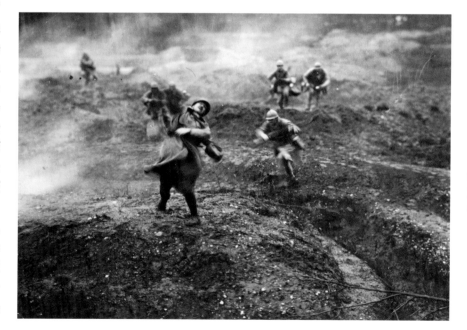

FIG. 19
Photographer unknown. Battle of Verdun, 1916.

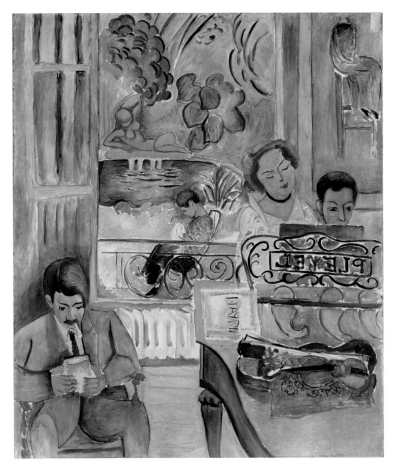

FIG. 20

Henri Matisse (1869–1954). *The Music Lesson (La Leçon de musique)*, summer 1917. Oil on canvas; 96 ½ x 83 in. (245.1 x 210.8 cm). The Barnes Foundation. © 2011 Succession H. Matisse, Paris/Artists Rights Society (ARS), New York, NY.

"Despite all the anguish and anxiety of this war, I have so focused on my work (a very important Decoration) that I am literally haunted by what I have done."[35] By the end of the year, he noted that he was even refining his decorations.[36] Monet's nationalistic impulse was evident on Armistice Day, November 11, 1918, when he gave his diptych *Green Reflections* to the French nation as a celebratory "bouquet of flowers."[37] Monet's work during this time attracted the attention of younger avant-garde colleagues, including Henri Matisse, who also struggled with justifying the practice of painting in wartime. Matisse visited Giverny in the spring of 1917 and was probably inspired by Monet's example to paint the pond in his own garden, which appears in the background of *The Music Lesson* (fig. 20).[38]

Monet's water-lily compositions can thus be seen as carrying a patriotic meaning, one that in fact recurred throughout his career. In a time of war, could he also have intended his focus on water lilies to reflect their association with Buddhism and peace? Indeed, Monet's nymphaea belong to the same genus as the lotus, associated in the East with purity. The extent to which the artist may have wished his triptychs to express the "spiritual" has indeed been the subject of recent debate.[39] His friend and biographer Gustave Geffroy saw Buddhist and pantheistic meaning in the late water-lily paintings. Clemenceau, who visited India in the early 1920s, also wrote about Monet's works in exalted, spiritual terms.[40] Monet's own correspondence and recorded statements, however, never explicitly reveal a similar viewpoint. He was an agnostic, and perhaps the closest we can come to such a reading is his ambition, as recorded by the American painter Theodore Robinson, to produce "mystery" in his late work, to infuse it with "more serious qualities" than he believed his earlier paintings contained.[41]

Monet and Decoration: "A Panorama of Water and Water Lilies"

Monet saw the *Agapanthus* triptych as part of a panoramic decorative ensemble that he envisioned lining the walls of an oval room and creating an immersive experience for the viewer. His idea for such a project dated from the mid-1890s, and his recorded statements indicate his wish that the installation be a kind of sanctuary.[42] He noted his intention to create a place where "nerves weighed down by work would be relaxed" and where one could experience "the asylum of peaceful meditation in the midst of a flowered aquarium."[43] He used his studio to imagine this expansive space. Photographs reveal that he put his paintings on wheeled trolleys so that they could be pushed together to create continuous stretches of canvas that would entirely surround him (see fig. 18). In so doing, Monet continued but also subverted an established nineteenth-century tradition of the panorama, at which viewers gazed down from above, providing them with a commanding view and sense of power. Monet, however, developed a very different concept by removing the horizon line from his images and placing the spectator in a low rather than elevated vantage point, thereby enhancing the immersive effect. The dealer René Gimpel described a disorienting experience during a visit to Monet's studio in 1918: "We were confronted by a strange artistic spectacle: a dozen canvases placed one after another in a circle on the ground all about two meters wide by one meter twenty high, a panorama of water and water lilies, of light and sky. In this infinity, the water and the sky had neither beginning nor end."[44]

Monet, by now a wealthy man, believed that his panels should not be sold but instead form a museum that would celebrate the glory of France and establish his name for posterity. He turned away several suitors who traveled to Giverny hoping to take possession of the panels. Among them were the dealers Gimpel and Gaston Bernheim-Jeune (the latter was already an established buyer of Monet's series paintings), who visited him in 1918.[45] Perhaps most interestingly, in the summer of 1920 Monet received a delegation from the Art Institute of Chicago; the group wished to buy an ensemble of the panels and devote the upper floor of the museum to their installation, following Monet's instructions.[46] This was a daring offer; the *Chicago Daily Tribune* later reported that the Chicago contingent offered the artist the spectacular sum of three million dollars for thirty large paintings.[47] Monet, however, resolutely refused to sell them and, by the fall of 1920, his museum suddenly seemed realizable. On September 27, 1920, Minister of Fine Arts Paul Léon visited Monet at Giverny, and the two men arrived at an unofficial agreement. Monet would make a gift to the nation of twelve panels—which comprised what he called his "four best series"—in return for a new museum constructed especially to house them. Among them was *Agapanthus*.[48]

Following Monet's recommendation, the well-known architect Louis Bonnier was selected to design the museum. Bonnier soon developed plans for a pavilion to be built in the garden of a Louis XV-era building in Paris, the Hôtel Biron. This had just opened in 1919 as a museum housing the work of Auguste Rodin, who had left much of his oeuvre to the nation. Monet very much welcomed the notion of a "Musée Monet" alongside a "Musée Rodin." He had long admired the sculptor, and the two men's joint retrospective exhibition in 1889 had secured the painter's national and international reputation. Monet's pavilion was to stand amid sculptures by Rodin installed in the mansion's grounds. The plan thus offered the possibility of bringing together in adjacent spaces work by arguably France's greatest contemporary painter and sculptor.

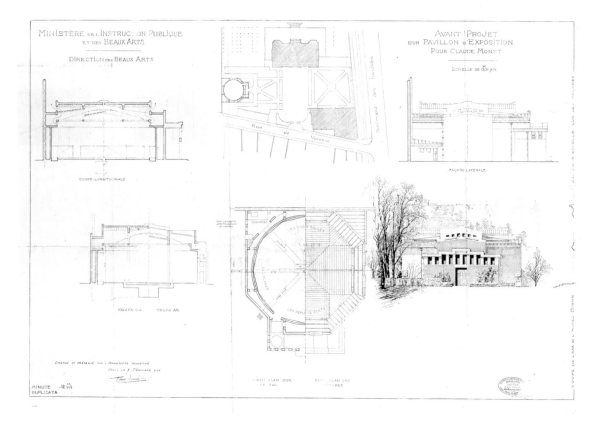

FIG. 21

Louis Bonnier (1856–1946). Piscine de la Butte-aux-Cailles, Paris, 1922–24.

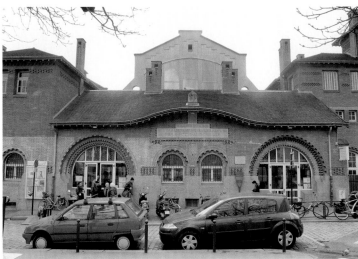

FIG. 22

Louis Bonnier. Plan of an exhibition pavilion for Claude Monet, Hôtel Biron, Paris, December 9, 1920. Clockwise, from top left: side elevation, location of the pavilion (circle at left) in Hôtel Biron garden, side elevation showing glass roof, view of façade, plan, and side elevation. Archives Nationales, Paris.

Monet's choice of Bonnier suggests that, at the age of eighty, the painter continued to aspire to an avant-garde identity. Bonnier had earned a significant reputation for his Art Nouveau buildings, often using new materials such as concrete and glass bricks. The nature of Bonnier's designs can be seen in his 1922–24 Piscine de la Butte-aux-Cailles, Paris (fig. 21), where the architect applied the same rigorous symmetry as in his designs for the Monet museum. Bonnier's plans for this museum are housed in the Archives Nationales, Paris, and contain architectural drawings (fig. 22), an "explanatory notice" of his aesthetic for the building, and cost estimates. Much of this material has never been published and provides considerable insight into this intriguing project. The architect's designs show a modernistic building made of reinforced concrete, brick, and cement (fig. 23). In describing his approach to the building, Bonnier articulated an understated approach: "For the exterior, we have not sought any effect for the planned building that might be detrimental to the architecture of the Hôtel Biron, but only a great simplicity, a quiet neutrality as a framework for the paintings of Claude Monet. For the interior,

likewise, no decoration with the same intention; at the very most a certain elegance provided by the the entrance door in wrought iron."[49] The architect's notes indicate that the brick and cement of the façade would have been painted white to underscore the "quiet neutrality," with a note of color provided only by the doorway. As we shall see, however, the degree to which his building complemented the Hôtel Biron (fig. 24) would become a point of contention.

In the panoramic presentation of the paintings that Bonnier planned, visitors would pass through a darkened vestibule before emerging into a wide, bright circular space naturally illuminated by skylights (fig. 25). Bonnier described the room thus:

> The large exhibition room, with a distinctive shape, and true to the instructions provided by the program of M. Claude Monet, measures a radius of 25 meters [some eighty feet] and is laid out in a way that allows the view of the ensemble, with the necessary space to step back from all the canvases. The lighting is obtained by means of a glass ceiling above the room. . . . The light is diffused by a vellum blind, placed under the entire glass surface. The horizontal glazing is high enough above the vellum to ensure, as much as possible, the diffusion of light.[50]

Crucially, visitors would have been able to see the entire ensemble of paintings when standing in the center of the room. In this plan, the works were placed alongside one another at an angle rather than glued to the walls, as would eventually be the case at the Orangerie.[51] Monet planned to show the four-panel *Three Willows* (fig. 26) opposite the diptych *Green Reflections* (fig. 27), and the triptych *Clouds* (fig. 28) opposite *Agapanthus* (fig. 29).[52] He carefully selected the components so that they would offset one another in terms of coloristic and compositional effect. The dominant tonality of intense blues and blue-greens in *Three Willows* and *Green Reflections* would thus have

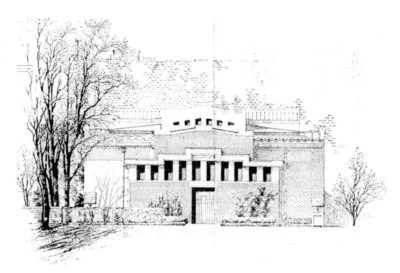

FIG. 23
Louis Bonnier. Façade of Monet pavilion (detail of fig. 22).

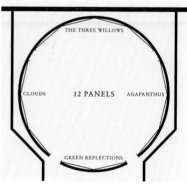

31

FIG. 25
Louis Bonnier. Proposed layout of the "Grandes Décorations" in Monet pavilion; based on December 9, 1920, plan (fig. 22).

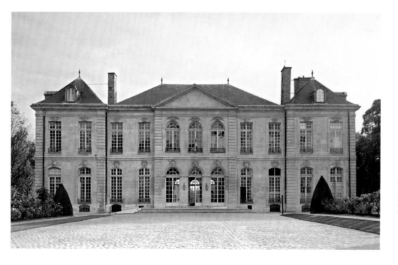

FIG. 24
Ange-Jacques Gabriel (1698–1782) and Jean Aubert (1680–1741). Hôtel Biron, Paris, 1728–31 (today Musée Rodin).

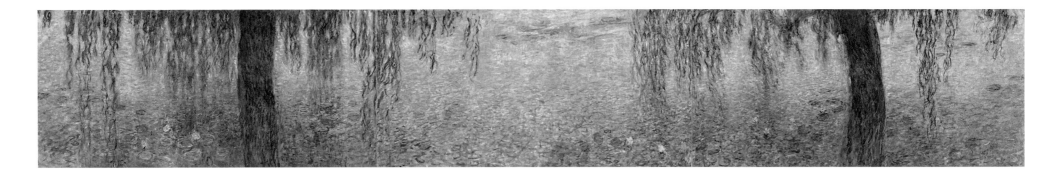

FIG. 26

Claude Monet. *Clear Morning
with Willows* (originally, the right
three panels of the four-panel
Three Willows), c. 1914–26.
Oil on canvas; 79 x 502 in.
(200.7 x 1,275.1 cm). Musée de
l'Orangerie, Paris.

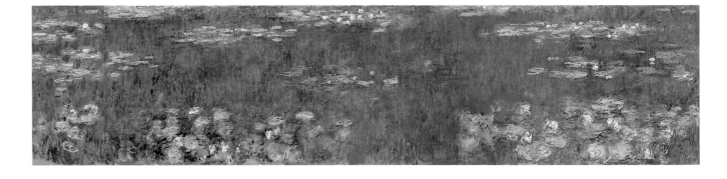

FIG. 27

Claude Monet. *Green Reflections*,
c. 1914–26. Oil on canvas; 79 x
335 in. (200.7 x 850.9 cm). Musée
de l'Orangerie, Paris.

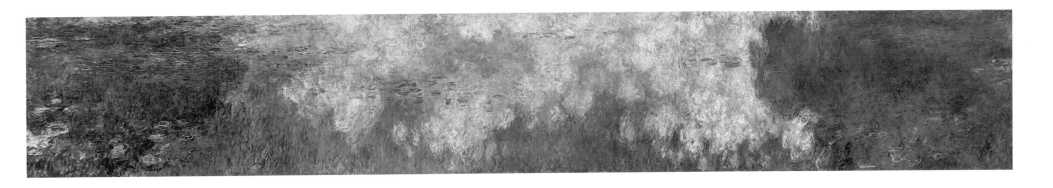

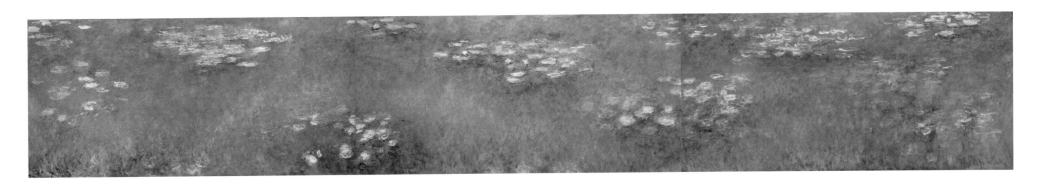

FIG. 28 (TOP)

Claude Monet. *Clouds*,
c. 1914–26. Oil on canvas;
79 x 502 in. (200.7 x 1,275.1 cm).
Musée de l'Orangerie, Paris.

FIG. 29 (BOTTOM)

Claude Monet. *Agapanthus*,
c. 1915–26. Oil on canvas;
79 ¼ (max.) x 502 ⅞ in. (201.3
[max.] x 1,277.3 cm). See fig. 1.

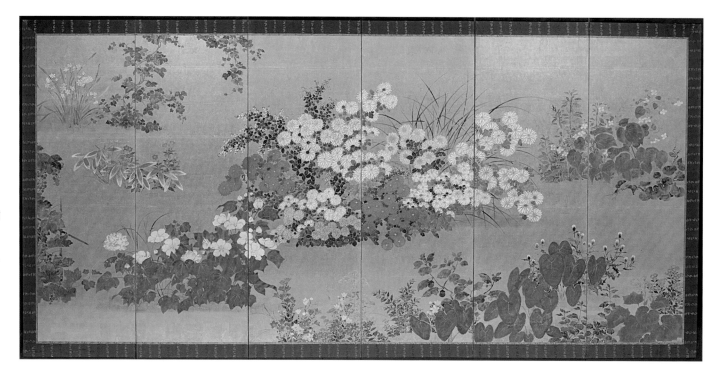

FIG. 30

Anonymous (Japanese, Edo Period, 1615–1868). *Flowers and Plants of the Four Seasons*, eighteenth century. One of a pair of six-panel folding screens. Ink, color, and gold leaf on paper; 65 x 139¾ in. (165 x 355 cm). Saint Louis Art Museum, Edwin and Betty Greenfield Grossman Endowment, 3:2010.2.

complemented the soft pinks and silvers of *Clouds* and the yellows of *Agapanthus*. The compositional format of the latter, with clusters of water lilies scattered across a plane of color, also mirrored that of *Green Reflections*, demonstrating Monet's continuing fascination with serial repetition. The decorative ensemble probably reflects his interest in Asian prototypes, particularly Japanese screens, or *byōbu*, which the artist could have seen at exhibitions in Paris in the late nineteenth and early twentieth century and which also often included floral subjects (see fig. 30).[53] The effect of unfurling space in Monet's paintings may also suggest his awareness of Chinese handscrolls.

Word of the "Musée Monet" project was soon reported in the press by critics who had recently been to the artist's studio. On

October 14, 1920, François Thiébault-Sisson wrote an extensive commentary in which he imagined the spectacular impact of the room on the visitor:

> He will have the illusion of finding himself in the midday summer sun on the island in the center of the water-lily pond in the artist's property at Giverny. . . . He will see the sky and its clouds reflected on the limpid mirror of calm water in touches of azure and gold and white tinged with pink: on their large round leaves, the nymphaea will show off their flowers, now yellow, now white, now purple, pink and violet . . . you will be amazed at this luminous enchantment, by harmonies in dark blue, pink and white, green and gold.[54]

Writing one week later, Alexandre also emphasized the immersive effect of the installation: "These decorations, placed very low, will seem to rise from the ground, and the spectator will be so to speak placed not only in the middle of the water lily pond . . . but completely immersed in the passion for color and dreams intensified a hundred times by the great artist." He described each of the panel groups referencing their dominant tonalities and noted that the glowing *Agapanthus* seemed to be painted in "molten gold."[55]

The ambition of Monet's decorative scheme can be grasped by examining one further element. The elevation plan for the rotunda indicates that a significant amount of space would have existed between the water-lily panels and the glass ceiling (see fig. 31). In fact Monet also planned an encircling frieze for the top of the room. This idea was later recorded by the writer Duc Édouard de Trévise, who had visited the artist's studio in the fall of 1920. Trévise suggested an arrangement wherein the water-lily panels would be situated below "the calm gray of the walls, crowned at the top by some sort of flowered frieze," to which Monet replied, "That is exactly my idea; I'll even show you the first garlands of this frieze; I am using wisteria for it."[56] Thiébault-Sisson noted a somewhat different plan to introduce decorative motifs only above the intervals between the water-lily groups "at the entrance and exit to the room and the corresponding intervals placed symmetrically opposite them."[57] The artist produced eight panels inspired by the swags of wisteria that hung from the trellis on his Japanese bridge.[58] In one diptych (fig. 32), he focused on the inverted arch created by the reflection of the bridge in the water. Monet rendered the shimmering reflections of wisteria blooms and their trailing vines in a range of colors including lilac, blue, green, and white. The artist's swirling brushstrokes ensure that the overall effect is close to abstraction. Had Monet completed his frieze, the wisteria blooms would have been repeated several times and formed a floral

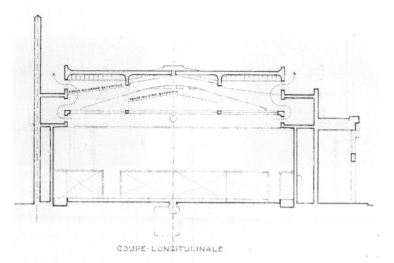

COUPE·LONGITUDINALE

FIG. 31

Louis Bonnier. Side elevation of Monet pavilion (detail of fig. 22). Bonnier listed a distance of 5.5 meters between the floor and the vellum blind that would diffuse light from the glass ceiling. This would allow for 3.5 meters between the top of Monet's panels and the blind. Note as well the very low height at which the panels would have been hung.

chain around the rotunda. Monet may have intended to reference his association with Rodin, since wisteria have long symbolized friendship. Importantly, too, his plan related closely to decorative notions associated with Art Nouveau. In fact the American designer Louis Comfort Tiffany had created a stained-glass frieze of wisteria as a surround in the dining room of his Laurelton Hall mansion, built in Oyster Bay, New York, in 1905. Monet may have known of it; Bonnier was familiar with Tiffany's work, having designed in 1895 the dealer Siegfried Bing's Maison de l'Art Nouveau, Paris, which included several stained-glass windows by Tiffany.[59]

Monet's series would have made an impressive decorative ensemble in Bonnier's rotunda. But by December 1920, the Bonnier plan had run into major problems. For construction to begin, it had to be approved by the General Council for Public Buildings. The project report prepared for the council, however, complained about the "forbidding appearance" of Bonnier's design, citing a lack of aesthetic similarity between its modernist look and that of the

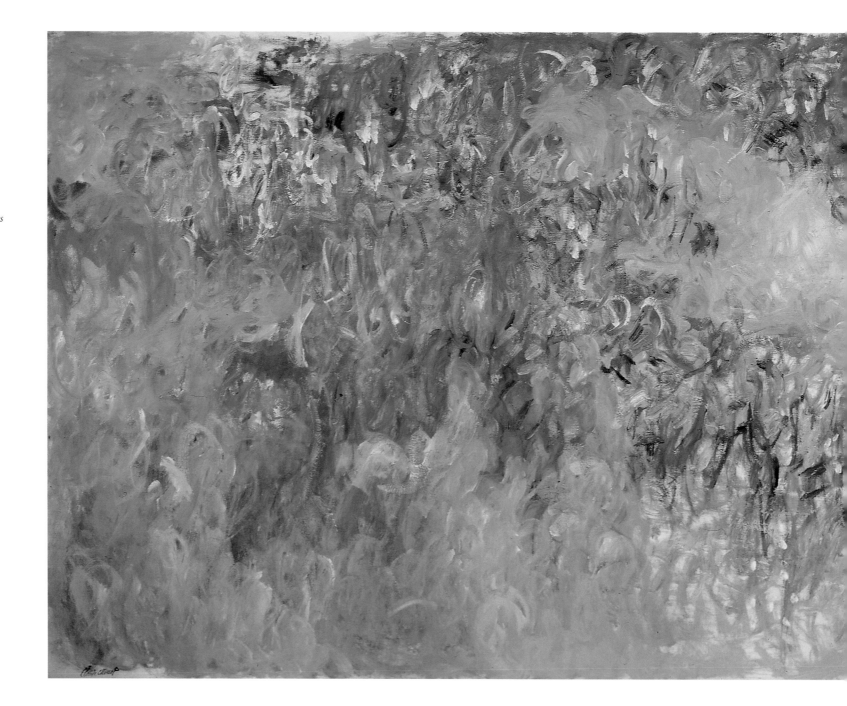

FIG. 32

Claude Monet. *Wisteria Numbers 1 and 2*, c. 1920. Oil on canvas; 59 x 158 in. (149.9 x 401.4 cm). Private collection.

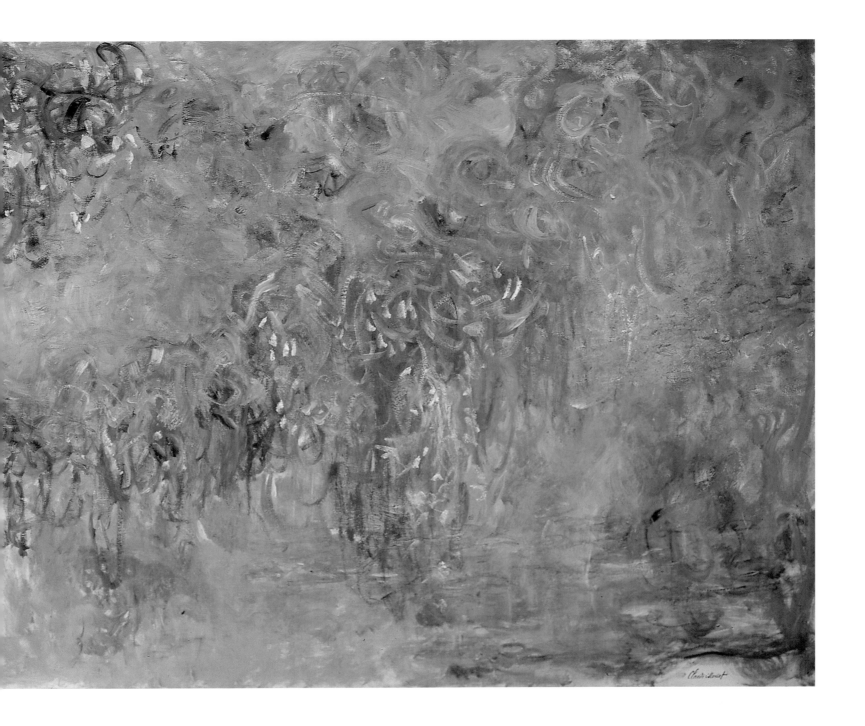

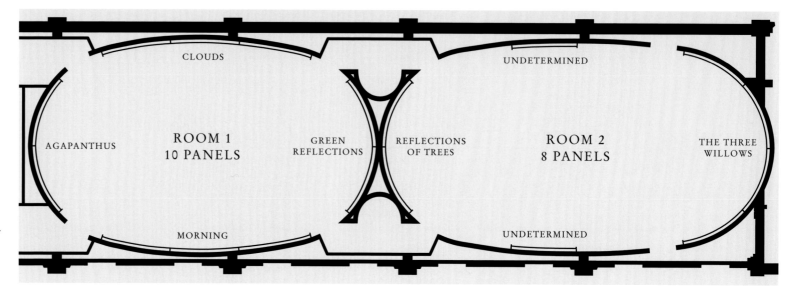

CLOUDS

UNDETERMINED

AGAPANTHUS

ROOM 1
10 PANELS

GREEN
REFLECTIONS

REFLECTIONS
OF TREES

ROOM 2
8 PANELS

THE THREE
WILLOWS

MORNING

UNDETERMINED

FIG. 33

Diagram of the *Grandes Décorations* in the Musée de l'Orangerie, Paris, based on a plan by Camille Lefèvre of January 20, 1922. The titles of the works are those Monet provided in a letter of November 9, 1921 (see note 61). Monet had probably envisioned a less-extended second room.

38

Hôtel Biron's Rococo architecture.[60] The potential expense of this new structure—budgeted for around six hundred thousand francs (or approximately $120,000)—was also put forward as a deterrent. The report thus recommended that the project not be pursued, and the council rejected it on December 23, 1920.

Monet and Bonnier continued to correspond, but the pavilion would never be realized. The letters between the two men indeed indicate their ongoing, complex debates regarding the angle and distance at which the panels should be viewed. Bonnier remained faithful to the idea of a circular gallery, while Monet developed a preference for a more elliptical space. By early 1921, the painter had begun to explore other options for the installation of his panels, focusing on the Orangerie, constructed in the Jardin des Tuileries in 1852 and recently acquired by the Administration of Fine Arts. The building had a checkered history, which included not only being used to grow oranges (hence its name) but also as an army barracks. The two oval

rooms in the Orangerie provided a narrower space than that of the pavilion; and the Orangerie's ceilings were lower than those designed by Bonnier, which meant that Monet could not realize his earlier plans for an encircling frieze of wisteria. But the new location did allow for a larger overall installation. By November 1921, Monet had developed a plan to give eighteen panels to the state. These included his willow paintings, which he wanted displayed in a separate room. *Agapanthus* was to be placed in the first room opposite *Green Reflections* and alongside *Clouds* and another triptych, *Morning* (see fig. 33).[61] As in the Hôtel Biron plan, the yellow-blue tones of *Agapanthus* would have offset the green-blues and silvery pinks of the other paintings in the room. Significantly, Monet now reduced the size of *Agapanthus* from a triptych to a diptych, probably in response to the new space. We do not know for sure which of the panels he chose to include, although his retention of the original title indicates that he may have chosen the left and central ones.

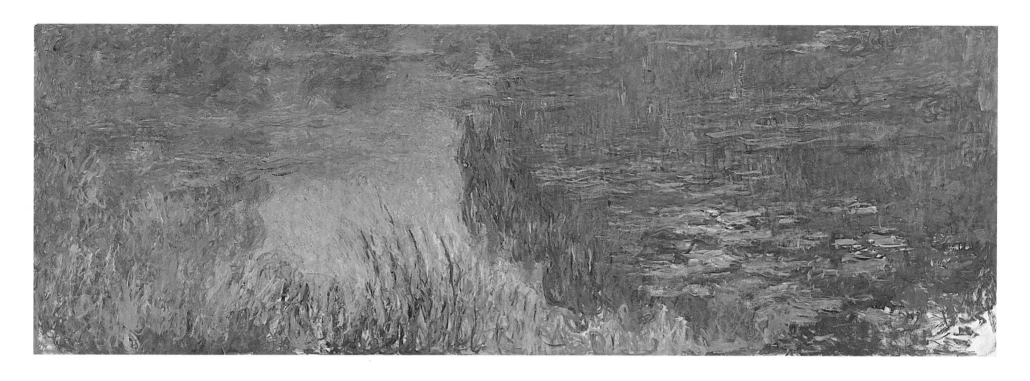

FIG. 34

Claude Monet. *Setting Sun*, c. 1914–26.
Oil on canvas; 78 ¾ x 236 ¼ in. (200 x
600 cm). Musée de l'Orangerie, Paris.

FIG. 35

Installation of *Setting Sun* in the
Musée de l'Orangerie, Paris, 2009.

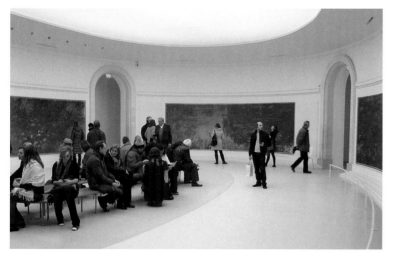

On April 12, 1922, Monet finally signed a formal contract with the state to deliver his ensemble of panels within two years. Importantly, the contract listed one major change. The *Agapanthus* diptych was replaced by a larger, single panel entitled *Setting Sun* (fig. 34). Why did Monet do this? Perhaps he was dissatisfied with his revisions of *Agapanthus* or perhaps simply desired to include a sunset scene in the Orangerie configuration. The intensely colorful *Setting Sun*—brighter in hue than *Agapanthus*—is the culmination of Monet's long-time interest in the light effects of sunset; its inclusion may reflect a new level of nuance in his conception of the decorative space of the Orangerie. Thus *Setting Sun* was installed at the western end of the building (see fig. 35), referencing dusk, while the morning scenes of willows were located at the eastern end, referencing dawn.

Late Changes and Vision Problems

After playing such a central role in Monet's initial decorative ensembles, *Agapanthus* was not ultimately included in the Orangerie installation. In his final years, the artist made extensive changes to the triptych, although we do not know exactly when. As we have seen, he was still thinking in early 1922 about including *Agapanthus* in the Orangerie ensemble, and it is very possible that he worked on the panels at this time. This, however, was a traumatic period, during which Monet struggled with deteriorating eyesight, the result of cataracts. On May 8, 1922, he wrote:

> The whole of the winter, I closed my doors to everyone. I felt that, without doing that, every day disappeared and I wanted to take advantage of the little sight I had to refine certain of my Decorations. And I was wrong. Because finally it's become clear to me that I ruined them, that I was incapable of producing anything beautiful. And I have destroyed several of my panels. Today I am nearly blind and I must give up working.[62]

Consultation with a doctor revealed that Monet was legally blind in one eye and had only ten percent of his vision in the other. In 1923 he underwent an ultimately successful operation to remove the cataracts, although his recuperation occupied much of 1924. His subsequent correspondence refers to his continuing work on several late panels. In January 1925, he wrote to his friend the painter Pierre Bonnard that he had just experienced "a fit of complete despondency" over his panels, which "obsessed" him. "I am going to make every effort to bring them back to life a little," he noted, "but it's a hopeless task."[63]

Monet's refusal to hand over his Orangerie canvases deeply frustrated Clemenceau, who complained that the artist was revising them excessively in order to produce "super-masterpieces."[64] Monet's late practice of reworking is clearly evident in *Agapanthus*, where the changes are considerable. As already discussed, examination of paint cross-sections has revealed the presence of several layers of pigment. We can only speculate about the degree to which these alterations—particularly an increased lack of definition—may have been due to Monet's vision problems. In the right panel, the artist painted over what had been discrete rafts of water lilies to create a far more diffuse effect. As x-radiographs show, slashing, crisscrossed brush marks transformed the flowers' distinct forms into abstractions (see Schafer and Bernstein, figs. 9–10). In addition the artist painted over most of the blossoms, which removed color accents from the painting. Of the ten blooms in the study (fig. 17), all of which existed in the early stage of the final panel, only one survives. The twisting crimson stems, which had suggested depth, also disappeared. Monet's addition of diaphanous veils of color—lavenders, blues, yellows, and pinks—enhanced the nuanced complexity of the panel's palette but also departed from the artist's original, more naturalistic vision, grounded in *plein-air* study.

Monet's changes to the central panel were less significant; here he eliminated from the foreground a raft of lilies and made the riverbank,

indicated now by lines of curving grass at the base, less prominent. He also painted over two blooms at the right of the panel. Perhaps most spectacular are the alterations the artist made to the left panel. Here he covered the entire agapanthus plant. As noted earlier, the plant had originally served as a repoussoir, situating the spectator on the riverbank. Its removal emphatically flattened the pictorial space, increasing the viewer's disorientation.[65] The collapsing of space is also evident at the bottom right, once occupied by the clump of water lilies with red stems that had suggested recession into the pool's depths. Over some ten years, Monet's triptych thus evolved from the illusion of three-dimensions to that of two, from the defined to the undefined, and ultimately—and perhaps most significantly—from naturalism to abstraction, with Monet fracturing the links to nature evident in the earlier configuration.

The Posthumous History

After Monet's death, on December 5, 1926, the panels intended for the Orangerie were finally moved from the artist's studio and glued to the walls of their new setting. *Agapanthus* remained at Giverny. It is impossible to know whether Monet considered it finished or not. Like other works still in the studio, its three sections were each marked with a rubber stamp, "Claude Monet," which replicated the artist's signature (see fig. 36). The triptych, owned by Monet's son Michel (1878–1966), stayed in the studio for nearly thirty years, unknown to a wider public. In 1955 it was acquired by the Parisian poet and art dealer Katia Granoff (1895–1989), who played an important role in reviving the reputation of Monet's late works in the 1950s. The following year, she included *Agapanthus* in a show at her Paris gallery of twenty-eight of his paintings from this period.[66] Soon after, she sold the triptych to the New York dealer Knoedler & Company.

FIG. 36

Claude Monet. Monet signature stamp (detail of fig. 39).

41

FIG. 37

Ellsworth Kelly (American, born 1923). *Tableau Vert*, 1952. Oil on wood; 29¼ x 39¼ in. (74.3 x 99.7 cm). The Art Institute of Chicago, Gift of the Artist, 2009.51. © Ellsworth Kelly.

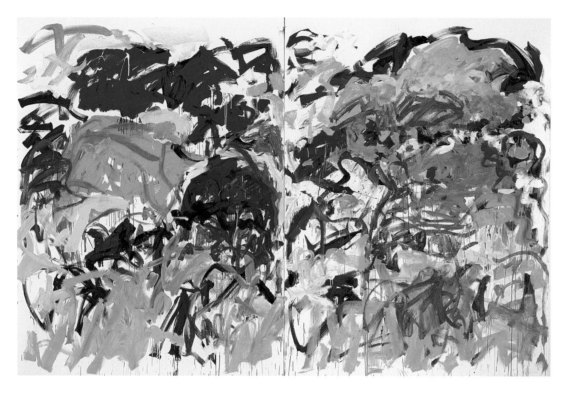

FIG. 38

Joan Mitchell (American, 1925–1992). *Ici*, 1992. Oil on canvas; left panel: 102 x 78 ¾ in. (259.1 x 200 cm), right panel: 102 x 78 ¾ in. (259.1 x 200 cm). Saint Louis Art Museum, Funds given by the Shoenberg Foundation, Inc., 89:1993a,b. © Estate of Joan Mitchell.

In October 1956, *Agapanthus* appeared in the exhibition of Monet's late work at Knoedler's with which this essay begins. It was an opportune moment, for Monet had now been rediscovered as an antecedent of the American abstract painters of the 1950s. For this the artists themselves were largely responsible. Ellsworth Kelly, for example, had become fascinated by Monet's work during his time in Paris in the late 1940s and early 1950s. The day after he visited Monet's studio at Giverny, he produced his first monochrome canvas, *Tableau Vert* (fig. 37), in homage to the artist. Barnett Newman also expressed interest in Monet's late canvases, and this interest would remain strong in the work of other artists associated with the Abstract Expressionist movement such as Joan Mitchell (see fig. 38).[67] The

1956 Knoedler show contained fourteen paintings, including several close-up studies of details of the lily pond such as *Water Lilies* (fig. 39), a view of bright lilac blooms and lily pads outlined in red. Three of the intensely colored Japanese-bridge pictures were also on view (see fig. 40). The *Agapanthus* panels, which were evidently displayed and sold as three discrete compositions for commercial reasons, were the largest paintings in the exhibition and attracted the greatest critical interest. Emily Genauer considered them the "loveliest" works in the show, in contrast to the smaller panels, which she thought were "too frothy or too picturesquely pretty," and the Japanese-bridge paintings, whose "hot autumnal palette that bursts into flames" struck her as "forced."[68] For the *New York Times* critic Howard Devree, the works were "almost incredible achievements." He noted, "Color and light are everything in them and black-and-white reproduction can give no idea of them. They must be seen and, one would almost say, heard."[69] Thomas B. Hess, who wrote for the prominent journal *Art News*, published a more nuanced commentary. He observed that Monet's extensive reworking of *Agapanthus* had contributed to a greater sense of generalization, in contrast to the precisely rendered forms in the artist's studies. Hess expressed a preference for Monet's more naturalistic vision, evident in the studies he found "more specific and more complete as pictures" (see fig. 39). Monet's revisions, Hess argued, obscured an original freshness and intensity of color: "Large areas of the pictures are toned with monochrome scumblings of neutral pigment. Bright brush marks are drowned in earth-green and grey-violet; clouds and vapors lie heavily on the lily pond. A few brilliant flowers float above—sometimes precariously above,

FIG. 39 (OPPOSITE)

Claude Monet. *Water Lilies*, c. 1916. Oil on canvas; 51 x 79 in. (129.5 x 200.7 cm). Private collection.

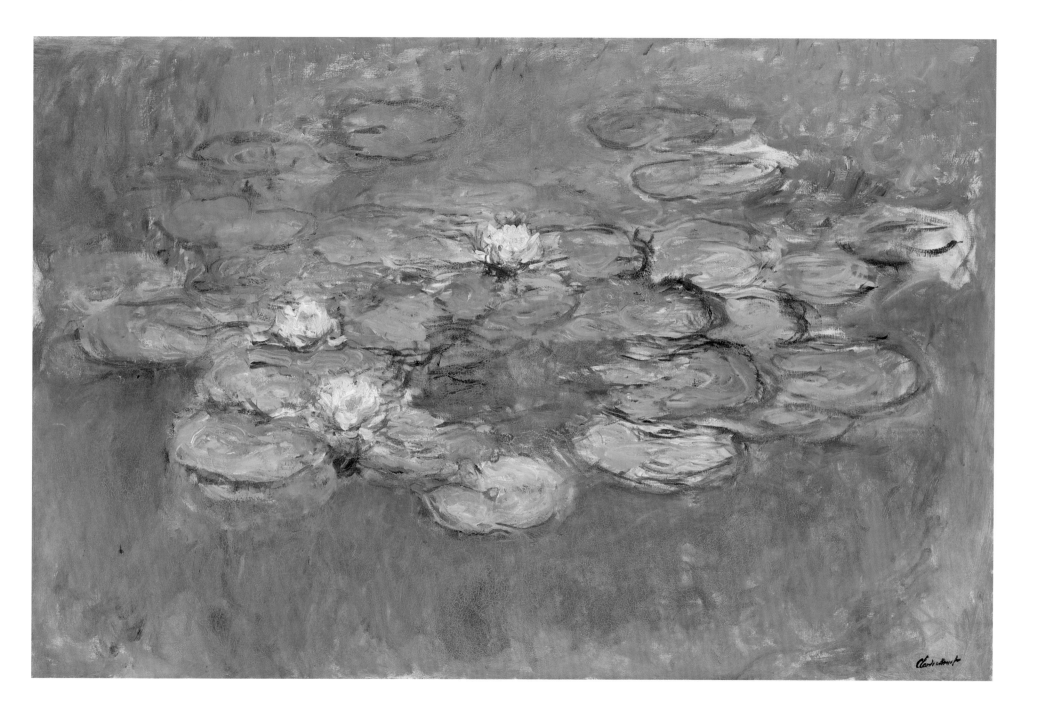

FIG. 40

Claude Monet. *The Japanese Bridge*, c. 1923–25. Oil on canvas; 35 x 45 ¾ in. (88.9 x 116.2 cm). Minneapolis Institute of Arts, Bequest of Putnam Dana McMillan.

appearing to swing into the air—the reflected atmosphere. . . . But what a wonderful amount of painting has vanished beneath the greyed layers of fog that close over to bring together these pictures."[70]

Despite such reservations, the exhibition was a commercial success, with all but one of the fourteen paintings finding buyers. Many private collectors were drawn to the smaller canvases; the St. Louis newspaper magnate Joseph Pulitzer, for example, purchased *Water Lilies* (fig. 39). The panels of the *Agapanthus* triptych attracted several museums, perhaps intent on emulating the example of the Museum of Modern Art, New York, which had acquired a late water-lily triptych in 1955, thus becoming the first American museum to do so.[71] As Genauer noted, "Today the three biggest water-lily paintings at Knoedler's are priced at $60,000 each and museums are dickering for the group."[72] Midwestern institutions led the way. The Saint Louis Art Museum bought the central panel in 1956. Encouraged by a long petition from art teachers and students at the Kansas City (Missouri) Art Institute, the Nelson-Atkins Museum of Art acquired the right panel in March 1957.[73] The Cleveland Museum of Art purchased the left panel in 1960.

The triptych was reunited in 1978 in an exhibition at the Metropolitan Museum of Art and the Saint Louis Art Museum and again in 1979–80 in shows at the museums of Kansas City, Cleveland, and St. Louis. On these occasions, the works were displayed in differing ways. In St. Louis, for example, they were shown unframed (see fig. 41). In Kansas City, the works remained in their museum frames, which obstructed the continuous flow between them (see fig. 42). For the exhibition that the museums in Kansas City, St. Louis, and Cleveland have now undertaken, a new frame has been designed to surround the entire triptych, thus allowing the edges of the paintings to sit directly alongside one another, as Monet intended. The frame closely resembles those in the Orangerie, which were made

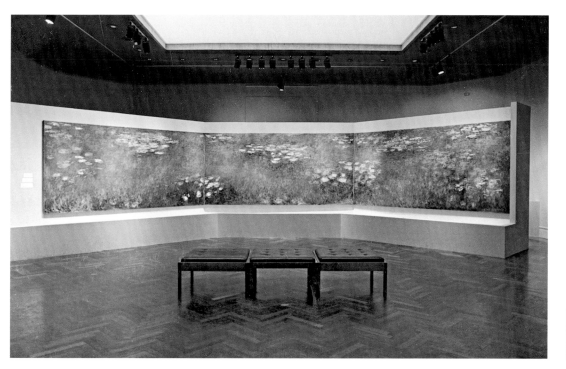

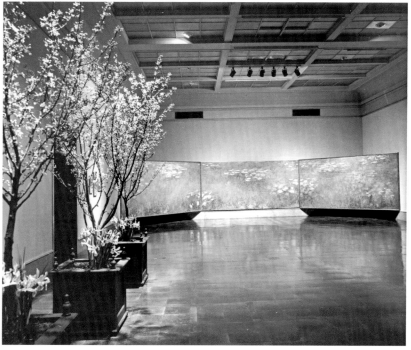

FIG. 41

Installation of *Water Lilies*
(figs. 1 and 29) in "Monet's
Years at Giverny: Beyond
Impressionism" at the Saint
Louis Art Museum, 1978.

FIG. 42

Installation of Monet's *Water
Lilies* (figs. 1 and 29) at the
Nelson-Atkins Museum of Art,
1979.

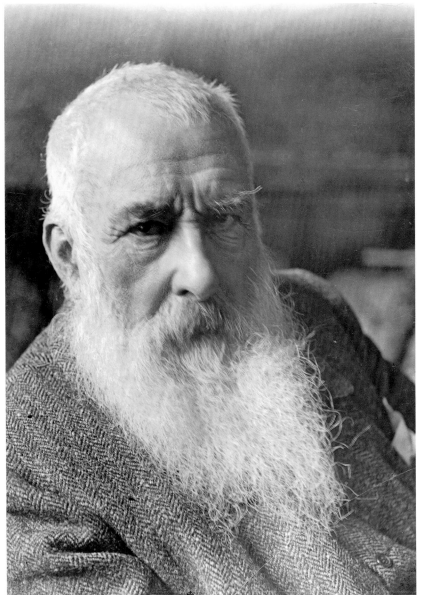

FIG. 43
Pierre Choumoff (Russian,
1872–1936). *Portrait of Claude
Monet*, 1920. © Pierre
Choumoff/Roger-Viollet.

46

under Monet's supervision. The new surround's two-finger width also reflects instructions Monet made on his deathbed.[74] Monet's interest in the framing of his works is, indeed, evident in the early photographs of *Agapanthus,* where it is clear that, even at this stage, he had added simple molded frames to his panels (see figs. 11–12 and 18).

Conclusion

What is the significance of *Agapanthus* for our understanding of Monet's artistic project? Certainly, it was a crucial work in the evolution of his "Grandes Décorations," playing a central role in his conception of himself as a decorative painter, a conception that dominated his late production. He struggled with the triptych, whose gradual evolution is documented in early photographs of his studio as much as any other water-lily composition. As we have seen, Monet included it in his plans for the Hôtel Biron. That it was the only one from the original group of four decorative suites he eliminated from the Orangerie installation suggests that he no longer regarded it as one of his "four best" triptychs. Nonetheless, *Agapanthus* is one of the most richly colored and nuanced of them all. Further study of Monet's revisions of other late paintings is required in order for us to determine the degree to which the extensive changes in *Agapanthus* is typical. The restless revisions of the *Agapanthus* panels clearly throw into question the *idée reçue* of Claude Monet as the archetypal Impressionist painter, producing pictures out of doors with spontaneous ease. Instead, *Agapanthus* reveals its creator to be a driven, even tormented, and completely modern artist. Something of Monet's angst is captured in a photograph (fig. 43) by the Russian photographer Pierre Choumoff, who visited the artist's studio in 1920. In this poignant image, Monet looks intensely ahead, as if in a quest for a level of perfection that he will never ultimately attain.

NOTES

All translations are by the author unless noted otherwise.

1. Emily Genauer, "Today's Artists Give Old Monets New Life," *New York Herald-Tribune*, Oct. 14, 1956. The exhibition, *Claude Monet: Les Nymphéas, Série de paysages d'eau*, exh. cat. (New York: Knoedler & Company, 1956), was on view Oct. 8–27.

2. On Nov. 28, 1918, Monet wrote in response to an inquiry from the Paris dealer Gaston Bernheim-Jeune about buying a single panel from a triptych: "Impossible. . . . Each one evokes the others for me." Quoted in René Gimpel, *Diary of An Art Dealer*, trans. by John Rosenberg with intro. by Herbert Read (New York: Farrar, Straus, and Giroux, 1966), p. 74.

3. Quoted in Duc [Édouard] de Trévise, "Le Pélerinage de Giverny," *La revue de l'art ancien et moderne* 51 (Jan.–May 1927), p. 131.

4. For example a work of 1919 that is much smaller than any of the triptych panels sold at auction for $80,379,591 (£40,921,250) at Christie's, London, on June 24, 2008.

5. For studies of the water-lily project, see Paul Hayes Tucker, "The Revolution in the Garden," in idem, with George T. M. Shackelford and Mary Anne Stevens, eds., *Monet in the 20th Century*, exh. cat. (New Haven/London: Yale University Press, 1998) pp. 14–85; and Tucker's more recent "Monet: Public and Private," in *Claude Monet: Late Work*, exh. cat. (New York: Gagosian Gallery, 2010), pp. 16–39. See also Virginia Spate, *Claude Monet: The Color of Time* (London: Thames and Hudson, 1992). For French scholarship, see the seminal catalogue raisonné by Daniel Wildenstein, *Claude Monet: Biographie et catalogue raisonné*, vol. 4 (Lausanne/Paris: Bibliothèque des Arts, 1985); and idem, *Monet, or the Triumph of Impressionism, Catalogue Raisonné*, vol. 4 (Cologne: Taschen, 1996) (the newer edition reproduces all works in color but does not include the correspondence). See also Pierre Georgel, *Monet, Le cycle des Nymphéas: Catalogue sommaire*, exh. cat. (Paris: Réunion des Musées Nationaux, 1999). For a recent study of Monet's relationship to decoration, see Sylvie Patry, "Monet et la décoration,"

in *Claude Monet, 1840–1926*, exh. cat. (Paris: Réunion des Musées Nationaux, 2010), pp. 318–25.

6. See Michael Leja, "The Monet Revival and New York School Abstraction," in Tucker et al. (note 5), pp. 98–108. See also Paloma Alarcó et al., *Monet et l'abstraction*, exh. cat. (Paris: Musée Marmottan Monet, 2010), which explores the impact of Monet's work on French and European abstract painting of the mid-twentieth century; and Ann Temkin and Nora Lawrence, *Claude Monet: Water Lilies*, exh. cat. (New York: Distributed Art Publishers/The Museum of Modern Art, 2009). In 1959 Greenberg wrote that Monet, at the end of his life, found what he was looking for "not in Nature, as he thought, but in the essence of art itself, in its 'abstract-ness';" idem, "The Later Monet" (1956, rev. ed. 1959), in *Art and Culture: Critical Essays* (Boston: Beacon Press, 1961), p. 41.

7. See Christoph Becker, ed., *Monet's Garden*, exh. cat. (Zurich: Kunsthaus, 2004); and Marina Ferretti Bocquillon, ed., *Monet's Garden in Giverny: Inventing the Landscape* (Milan: 5 Continents

Editions/Giverny: Musée des Impressionismes, 2009).

8. See Charles F. Stuckey et al., *Monet, L'oeil impressionniste*, exh. cat. (Paris: Éditions Hazan/Musée Marmottan Monet, 2008).

9. See Steven Z. Levine, *Monet, Narcissus and Self-Reflection: The Modernist Myth of the Self* (Chicago: University of Chicago Press, 1994).

10. Monet noted that he had produced "45 to 50 panels constituting about fourteen series, 4 of which I have assigned to the State. These panels all measure 4.25 by 2 meters high. Only 3 comprise a single panel that measures 6 by 2;" Monet to Arsène Alexandre, Dec. 6, 1920, in Wildenstein (note 5), letter 2391.

11. André Masson, "Monet le fonda-teur," *Verve* 7, 27–28 (1952), p. 68.

12. Arsène Alexandre, *Claude Monet* (Paris: Bernheim-Jeune, 1921), p. 120.

13. These results are based on techni-cal analysis of cross-sections of the right panel. Pigment identification is based on the results of field emission scanning electron microscopy with energy dispersive x-ray spectrometry performed at Rutgers University

by Lauren A. Klein. *Agapanthus*'s palette relates closely to that of *Water Lilies* in the National Gallery, London; see Ashok Roy, "Monet's Palette in the Twentieth Century: *Water-lilies* and *Irises*," *National Gallery Technical Bulletin* 28 (2007), pp. 58–68.

14. Roger Marx, "Les Nymphéas de M. Claude Monet," *Gazette des beaux-arts* 4, 1 (June 1909), pp. 523–31.

15. "Toward the end of his life, Monet began to make his pictures all foreground;" Greenberg (note 6), p. 44.

16. Monet to the prefect of the Eure, July 17, 1893, in Wildenstein (note 5), letter 1219.

17. See Charles F. Stuckey, "The Predications and Implications of Monet's Series," in Eik Kahng, ed., *The Repeating Image: Multiples in French Painting from David to Matisse* (New Haven/London: Yale University Press, 2007), pp. 83–126.

18. See Marcel Proust, *Swann's Way*, vol. 1, *In Search of Lost Time* (1913), trans. by C. K. Scott Moncrieff and Terence Kilmartin, rev. by D. J. Enright (New York: Modern Library, 2003), p. 239. For Mallarmé's poem, see Stéphane Mallarmé, *Selected Poetry and Prose* (New York: New Directions, 1982), ed. by Mary Ann Caws, trans. by Bradford Cook, pp. 65–67.

19. For this comparison, see also Marx (note 14).

20. Translation by John House, in idem, *Monet: Nature into Art* (New Haven/London: Yale University Press, 1986), p. 221. François Thiébault-Sisson recorded Monet's words during a visit he made to the artist's studio in Feb. 1918; François Thiébault-Sisson, "Un nouveau musée parisien. Les nymphéas de Claude Monet à l'Orangerie de Tuileries," *Revue de l'art ancien et moderne* 52 (June 1927), p. 44.

21. Quoted in Antonin Proust, *Édouard Manet: Souvenirs* (Paris: Librarie Renouard, 1913), p. 84.

22. Monet to Gustave Geffroy, Aug. 11, 1908, in Wildenstein (note 5), letter 1854.

23. Proust understood this. He wrote, "If I can someday see M. Claude Monet's garden, I feel sure that I shall see something that is not so much a garden of flowers as of colors and tones, less an old-fashioned flower garden than a color garden, so to speak." Marcel Proust, "Splendors," *Le Figaro*, June 15, 1907; quoted in Charles F. Stuckey, ed., *Monet: A Retrospective* (New York: Hugh Lauter Levin Associates, 1985), p. 250.

24. In 1894, shortly after completing his pond, Monet placed a very large order for water plants with Latour-Marliac. It included five types of lotus (which failed to grow) and three pairs of water lilies (the date after a plant's name in the lists that follow indicates year of hybridization): two yellow *Nymphaea Flava* (syn. *Nymphaea Mexicana*; "species of Florida"); two pink *Nymphaea Laydekeri Rosea* (Latour-Marliac, 1892); two yellow *Nymphaea Sulfurea Grandiflora* (Latour-Marliac, 1888). In 1904 the artist bought four water-lily plants, including recently created breeds: one dark-red *Nymphaea Atropurpurea* (Latour-Marliac, 1901); one pink-red *Nymphaea Arethusa* (Dreer, 1902); one dark-red *Nymphaea William Falconer* (Dreer, 1899); one dark-pink *Nymphaea James Brydon* (Dreer, 1899). See "What Monet ordered" on www.latour-marliac.com (accessed Mar. 15, 2010).

25. Monet to Raymond Koechlin, Jan. 15, 1915, in Wildenstein (note 5), letter 2142.

26. Private collection; ibid., 1803.

27. Monet was not happy with the photograph, and it was not included in the publication: "I have just spent three days that have somewhat irritated me, forced me to cease all work and to turn my entire studio upside down and hand it over to the employees of [the photographer] M. André Marty, and to what end? I dare not imagine after what I saw being done." Monet to Gaston and Josse Bernheim-Jeune, Feb. 16, 1921, in Wildenstein (note 5), letter 2407. The photograph was first published by Robert Gordon and Charles F. Stuckey in "Blossoms and Blunders: Monet and the State." *Art in America* 67, 1 (Jan.–Feb. 1979), pp. 112–13. There the triptych was incorrectly identified as "now lost." In a second article published shortly thereafter, Stuckey corrected his earlier statement, noting for the first time the connection between the photograph and *Agapanthus*: "Although we claimed that the panels . . . are now lost, it seems likely that they exist, extensively repainted, as parts of a dispersed triptych in museums in Cleveland, St. Louis and Kansas City." Charles F. Stuckey, "Blossoms and Blunders: Monet and the State, II" in *Art in America* 67, 5 (Sept. 1979), p. 125.

28. There are two other large-scale oil studies of the agapanthus plant. One is in the Museum of Modern Art, New York, and the other in the Musée Marmottan Monet, Paris. See Wildenstein (note 5), 1821–22. As Robert Gordon has suggested to me (personal correspondence), Monet seems to have used another study (Wildenstein [note 5], 1785; private collection) as the basis for the group of blooms and pads at the top center of the Cleveland panel (figs. 1 and 29, left panel).

29. Paul Hayes Tucker, *Claude Monet: Life and Work* (New Haven/London: Yale University Press, 1995).

30. Monet to Georges Durand-Ruel, Jan. 17, 1916, in Wildenstein (note 5), letter 2168.

31. Monet to Geffroy, Sept. 11, 1916, in ibid., letter 2193.

32. Monet to Geffroy, Dec. 1, 1914, in ibid., letter 2135.

33. Alexandre (note 12), p. 118.

34. Monet to Thérèse Janin, Mar. 2, 1916, in Wildenstein (note 5), letter 2173.

35. Monet to P. Desachy, Aug. 26, 1916, in ibid., letter 2191.

36. Monet to Gaston or Josse Bernheim-Jeune, Nov. 28, 1916, in ibid., letter 2205.

37. See Gustave Geffroy, *Claude Monet: Sa vie, son oeuvre* (Paris: Éditions G. Crès & Cie., 1924), vol. 2, p. 190.

38. On Nov. 28, 1916, Monet agreed to a visit from Henri Matisse, who wanted to see his recent work; Wildenstein (note 5), letter 2205. On May 1, 1917, he invited Matisse to lunch at Giverny; ibid., letter 2229. See Tucker, "The Revolution in the Garden" (note 5), p. 70.

39. See Paul Hayes Tucker, "Reflections on Monet's Late Work" in "Impressionisme(s): Nouveaux chantiers" (symposium, Musée d'Orsay, 2009), for an argument for the significance of the spiritual in Monet's work. The opposing viewpoint is articulated by Richard Kendall in "Painting without God," in *Painting Quickly, Lasting Impressions*, exh. cat. (Williamstown, Mass.: Sterling and Frances Clark Museum of Art, 2001), pp. 1–5.

40. "This is the supreme significance of the art of Monet, of his adoration for the universe that results in a pantheistic and Buddhist contemplation;" Geffroy (note 37), p. 193. Clemenceau described the *Nymphéas* as evoking Monet's aim to capture "scarcely perceptible aspects of a light reflected from things radiating through the endless universe;" Georges Clemenceau, *The Water Lilies*, trans. by George Boas (New York: Doubleday, Doran & Co., 1930), p. 36.

41. Robinson wrote: "It [a painting by Jean-François Raffaelli] has a good deal of Monet's desideratum, mystery" (June 19, 1892); and "A good criticism by Monet of a canvas of [Ferdinand] Deconchy . . . not observed closely enough—too little mystery" (July 29, 1892). On June 3, 1892, Robinson noted that Monet had said that he could no longer paint "anything that pleased him, no matter how transitory" and was looking instead for "more serious qualities." All of the above is quoted in House (note 20), pp. 201 and 223. For these and further extracts from the diary, see "Diary of Theodore Robinson. References to Claude Monet, 1892–1896," in Sona Johnston, *In Monet's Light: Theodore Robinson at Giverny*, exh. cat. (London: Philip Wilson Publishers, Ltd./Baltimore: Baltimore Museum of Art, 2004), pp. 189–99.

42. In 1898 Monet was documented as saying,

> Imagine a circular room in which the dado . . . is completely covered by an expanse of water dotted with aquatic flora, the walls a transparent vision of alternating greens and mauves, the calm and silence of the still water reflecting the blossoming panorama; the tones are imprecise, beautifully nuanced with the delicacy of a dream. . . . This decorative vision is peace and quiet."

Quoted in Maurice Guillemot, "Claude Monet," *La revue illustrée* 13 (Mar. 15, 1898), p. 1.

43. Quoted in Marx (note 14), p. 529.

44. The paintings' measurements are incorrectly noted as six feet high in Rosenberg's translation; Gimpel (note 2), p. 60. For the original reference to a height of two meters, see René Gimpel, *Journal d'un collectionneur, Marchand de tableaux* (Paris: Calmann-Levy, 1963), p. 68.

45. Ibid.

46. The delegation comprised Mrs. Charles Hutchinson (wife of president of the Art Institute's board of trustees), and Chicago collectors Mr. and Mrs. Martin A. Ryerson. François Thiébault-Sisson, "Art et curiosité: Un don de M. Claude Monet à l'État," *Le Temps*, Oct. 14, 1920.

47. Monet's obituary, *Chicago Daily Tribune*, Dec. 6, 1926.

48. "I am leaving my four best series to the French State, which will do nothing about it;" Trévise (note 3), p. 131.

49. À l'extérieur, on n'a recherché pour la construction projetée aucun effet qui fût de nature à nuire à l'architecture de l'Hôtel Biron, mais seulement une grande simplicité, une neutralité discrète pour l'encadrement des peintures de Claude Monet. De même, à l'intérieur, aucune decoration dans le même but; tout au plus, une certaine recherche dans la porte d'entrée en fer forgé.

Louis Bonnier, "Notice explicative," in "Avant Projet d'un Pavillon d'Exposition pour une série de toiles de Monsieur Claude Monet," Paris, Archives Nationales, MS F 21–6028. Bonnier also described the "façade en brique blanche de Dizy, joints en creux, au ciment, dégageant l'arête . . . toutes les parties vues du béton armé seront enduites en ciment blanc." A number of Bonnier's drawings were first published in Robert Gordon and Andrew Forge, *Monet* (New York: Harry N. Abrams, 1983), pp. 232–35.

50. La grande salle d'exposition, de forme special, et conforme aux indications fournies par le programme de M. Claude Monet, mesure 25m 00 de rayon et est disposé de façon à permettre la vue d'ensemble, avec les reculs necessaires de toutes les toiles. L'éclairage est obtenu au moyen d'un plafond vitré place au-dessus de toute la salle. . . . La lumière est tamisée par un vélum placé sous toute la surface vitrée. Le vitrage horizontal est assez élevé au-dessus du vélum pour assurer, autant que possible, la diffusion de la lumière.

Bonnier (note 49). There is a discrepancy between the radius of the room as cited here and that in Bonnier's plan (fig. 22), where the radius is 18.5 meters (2 x 9.25 m).

51. Even though the *Agapanthus* triptych is not noted in Bonnier's architectural plan, it is clear that it was intended for the installation. Bonnier often referred to *Agapanthus* in his correspondence. On Oct. 5, 1920,

for example, he discussed the possibility of an elliptical room while also itemizing the difficulties associated with this:

> 1. The angles of the canvases are going to be different . . . 'clouds' and 'agapanthus' will be tighter than 'three willows' and 'green reflections.' 2. The amount of space to stand back from 'three willows' which are 17m wide will be less than from 'agapanthus' which is 12.75. It seems that it ought to be the reverse.

Quoted in Georgel (note 5), p. 225. Bonnier again mentioned *Agapanthus* in a similar argument he made in a letter to Monet of Feb. 9, 1921 (ibid., p. 226). Monet's correspondence indicates that he preferred an elliptical to a circular interior (which Bonnier favored) for the Hôtel Biron pavilion. See, for example, Monet to Paul Léon, Feb, 11, 1921, Wildenstein (note 5), letter 2406.

52. Monet broke up the four-panel *Three Willows* in the Orangerie installation, with its left panel forming that of *Morning with Willows* and its other three panels forming the triptych *Clear Morning with Willows*. *Clouds* and *Green Reflections* remained in their original configurations in the Orangerie, although with compositional revisions. Questions remain about the clear identification of the Biron *Clouds* and *Green Reflections* (Monet produced other panels with these titles), as Wildenstein mentioned (note 5), pp. 318–19, 328–29.

The Orangerie paintings, however, are the most likely candidates.

53. See Akiko Mabuchi, "Monet and Japanese Screen Painting," in *Monet and Japan*, exh. cat. (London: Thames and Hudson, 2001), pp. 186–94. Monet could have become familiar with the Zen Buddhist conception of nature through direct contact with the Japanese gardener he mentioned in his correspondence (Monet to Paul Helleu, June 9, 1891, Wildenstein [note 5], letter 1111 bis); the dealer Tadamasa Hayashi; or the collector M. Kuroki and his wife (née Matsukata), who visited Giverny. Edmond de Goncourt referenced two Hokusai screen panels in the possession of "'M. Monnet' [*sic*], a landscape painter;" see Matthi Forrer, *Hokusai*, with texts by Edmond de Goncourt (New York: Rizzoli, 1988), p. 374.

54. Thiébault-Sisson (note 46).

55. See Arsène Alexandre, "L'Épopée des Nymphéas," *Le Figaro*, Oct. 21, 1920.

56. Trévise (note 3), pp. 130–31.

57. Thiébault-Sisson (note 46). He also said, "The glass ceiling will be high enough so that between the lower part of the glass and the canvases there will be a space wide enough for . . . Monet to fill with decorative motifs, here and there above the gaps separating the series." Translation by Gordon and Forge (note 49), p. 233.

58. Three of the wisteria panels are strongly horizontal, a format that lends itself to the idea of a frieze, while the other five (including

fig. 32) are slightly more square, suggesting that they may have been more suited to the plan described by Thiébault-Sisson, whereby the wisteria would bridge the gaps above the water-lily panels. See Wildenstein (note 5), nos. 1903–10. For a discussion of *Wisteria Number 1 and 2* (fig. 32), see Charles Scott Chetham, ed., *Modern Painting, Drawing and Sculpture Collected by Louise and Joseph Pulitzer, Jr.*, exh. cat. (Cambridge, Mass.: Fogg Art Museum, 1971), vol. 3, pp. 485–88.

59. For the broader context of early twentieth-century decoration, see Gloria Groom, *Beyond the Easel: Decorative Painting by Bonnard, Vuillard, Denis, and Roussel, 1890–1930*, exh. cat. (New Haven/London: Yale University Press/Chicago: Art Institute of Chicago, 2001).

60. "un aspect rebarbatif, . . . un manque d'harmonie complet entre cette construction et la façade de l'Hôtel Biron," in "Rapport fait au Conseil [Conseil général des Bâtiments Civils] de Mons. Ch. Girault, Membre de l'Institut;" Paris, Archives Nationales, MS F 21-6028. A commentary written a few months later points to the anti-establishment status of Bonnier as another reason for the decision: "Proposed in conformity with the regulations of public administration to the Council on Public Buildings, the project was unanimously condemned. The primary objection is that it did not issue from someone 'in house.'" Anonymous, "Le Musée

des Nymphéas," *Bulletin de la vie artistique* (Apr. 15, 1921), p. 230. Despite this rejection, Léon continued to support the plan. On January 6, Bonnier's original estimate of 579,000 francs was amended by a second architect, Camille Lemonnier, to a new and larger figure of 626,000 francs. See "Devis estimatif," in "Avant Projet d'un Pavillon d'Exposition" (note 49). In the end, it was Monet who was finally responsible for the abandonment of the project; he wrote to Léon in Feb. 1921 to express his dislike for the "too regular" circular building form, noting that a condition of his gift to the State was that the work be produced to his stipulation; Wildenstein (note 5), letter 2406. Bonnier continued to show interest in the *Water Lilies* project; in Dec.1921, he provided Monet with a plan to install the works in the Orangerie. By then, however, the government had awarded the contract to Camille Lefèvre, architect of the Musée du Louvre. Lefevre's plans for the transformation of the Orangerie (dated Jan. 20, 1922, and Mar. 7, 1922) are housed in the Archives Nationales.

61. "I am making a gift to the State of 18 decorative panels. . . . These eighteen panels are destined for two rooms arranged in oval form [in the Orangerie], with the following in the entry room: Green Reflections: 2 panels—Agapanthus: 2 panels—Clouds: 3 panels—Morning: 3 panels. For the second room: The Three Willows: 4 panels—Tree Reflections: 2 panels—in addition 2 panels of 6

meters wide not yet determined." Monet to Paul Léon, Nov. 9, 1921, in Wildenstein (note 5), letter 2463. The diagram in ibid., p. 327A, is incorrect in including four panels, each with a width of six meters.

62. Monet to Marc Elder, May 8, 1922, in ibid., letter 2494. In Oct. 1922, Elder reported Monet's practice of destroying his canvases:

I saw the frames in the back of the workshop against the wall, those big frames on which Claude Monet fixed those ephemeral confessions of his water-lily pond. Shreds of torn canvas hung on the edges. The trace of the knife is still vivid, and the painting bleeds like a wound. The nails are in place; the canvas is still stretched. A raging hand . . . lacerated the panels without bothering to take the canvas off patiently as one would with a precious rug being put away. . . . Under the table is the pile of canvases that the servants have been ordered to burn.

Marc Elder, À Giverny: Chez Claude Monet (Paris: Bernheim-Jeune, 1924), pp. 81–82.

63. Monet to Pierre Bonnard, Jan. 19, 1925, in Wildenstein (note 5), letter 2590.

64. On Oct. 8, 1924, Clemenceau wrote to Monet: "You wanted to make super-masterpieces—and with an impaired visual faculty that you yourself refused to have corrected." Quoted in "Pièces documentaires," in Georgel (note 5), D73.

65. See entry on the panel by Roger Diederen in European Paintings of the 19th Century, vol. 2, ed. by Louise d'Argencourt with Roger Diederen (Cleveland: Cleveland Museum of Art, 1999), pp. 458–62. See also Lynn Federle Orr, Monet in Normandy (New York: Rizzoli, 2006), pp. 178–81.

66. The exhibition, "Les grandes évasions poétiques de Cl. Monet," took place at the Galerie Katia Granoff from June 1–30, 1956. The show featured twenty-eight water-lily paintings, not all of which have been identified. See Hiroo Yasui, "The European Monet Revival of the 1950s and 1960s and the Role of Katia Granoff," in Monet, Later Works: Homage to Katia Granoff, exh. cat. (Morioka: Iwate Museum of Art et al., 2001), pp. 115–30. See also Joseph Baillio, "Katia Granoff (1895–1989): Champion of the Late Works of Claude Monet," in Claude Monet (1840–1926): A Tribute to Daniel Wildenstein and Katia Granoff, exh. cat. (New York: Wildenstein Gallery, 2007), pp. 34–44.

67. For Kelly, see Carol Vogel, "Inside Art," New York Times, Apr. 16, 2009. For Newman's interest in Monet, see "Open Letter to William A. M. Burden, President of the Museum of Modern Art," in Barnett Newman, Selected Writings and Interviews (Berkeley: University of California Press, 1992), pp. 38–40. For Mitchell, see Joan Mitchell, ed., Nils Ohlsen, exh. cat. (Heidelberg: Kehrer Verlag, 2008), p. 55.

68. Genauer (note 1).

69. Howard Devree, "Modern Pioneer," New York Times, Oct. 10 or 14, 1956. For a discussion of the reviews of the Knoedler exhibition, see Eric Zafran, "Monet in America," in Claude Monet (1840–1926) (note 5), pp. 129–30.

70. Thomas B. Hess, "Monet: Tithonus at Giverny," ARTnews 55 (Oct. 1956), p. 53.

71. For the story of this acquisition, as well as that of the destruction of the work in a fire at the Museum of Modern Art, New York, see Temkin and Lawrence (note 6).

72. Genauer (note 1).

73. According to Edye Weissler of the Knoedler Archives, the Nelson-Atkins Museum's Water Lilies was purchased by Knoedler's from Katia Granoff in July 1956 and sold to the museum on Mar. 20, 1957, for $40,000. In early 1957, the painting hung in the Nelson-Atkins on consignment from Knoedler's, but trustee minutes suggest reluctance to acquire the picture. The petition from students and teachers at the Kansas City Art Institute, dated Jan. 7, 1957, states:

Dear Sirs, We, the undersigned students at the Kansas City Art Institute and School of Design feel very strongly that the gallery should make every effort to obtain the Monet canvas 'Waterlilies' upon which, we understand, the gallery has a purchase option. If, as we understand, the gallery does not intend to acquire this painting because of the fact that its size would create some display problems, we suggest that the immense value of this painting as a work of art would make worthwhile the re-distribution or perhaps even the removal from display of a number of lesser canvases interesting only from a historical viewpoint.

The petition, which contains fifty-five signatures, is in the Nelson-Atkins Museum archives. Thanks to Meghan Gray for this information.

74. See Louis Gillet, Trois variations sur Claude Monet (Paris, 1927; new ed., Paris: Éditions Klincksieck, 2010), p. 112.

MARY SCHAFER AND JOHANNA BERNSTEIN

The Evolution of Monet's Water Lilies: A Technical Study

OVER THE ROUGHLY TEN YEARS in which Claude Monet worked on *Agapanthus*, its three panels underwent significant changes as the artist developed and reworked them. A technical study of the triptych's right panel, *Water Lilies* (Kelly, figs. 1 and 29; The Nelson-Atkins Museum of Art), provided an opportunity to explore this process from the point of view of the artist's materials. The painting was examined using a variety of techniques, including raking light, ultraviolet radiation, infrared radiation, magnification, and x-radiography. Samples of the paint and ground were analyzed using ultraviolet/visible light microscopy. Results from this study support the art-historical research and documentary photographs that Simon Kelly describes in his essay. Here we present details about the overall construction of *Water Lilies*, Monet's use of a preparatory sketch, the compositional reworking that followed, and how the color palette shifted in the final painting stages.[1]

Above the white ground, Monet first marked the location of the water lilies with thin, loosely sketched outlines, some of which remain visible today. He then added background colors around the water lilies. This progression is evident in a preparatory study (Kelly, fig. 15) for the triptych's left panel, where the lily pads were left undeveloped and their rough outlines are apparent.

Visual examination and cross-section analysis of the Kansas City *Water Lilies* reveal initial background colors that resemble those of the study related to it (Kelly, fig. 17). The study is loosely divided into three horizontal bands of color: purple along the top, shades of yellow and green across the center, and green on the lower third. Cross-sections from *Water Lilies* contain initial layers of lavender (fig. 1), greenish yellow (fig. 2), and green (fig. 3) that correspond to the general color and location of the bands in the study.[2] The layer of yellow paint in figure 1 (third layer from the bottom) may also

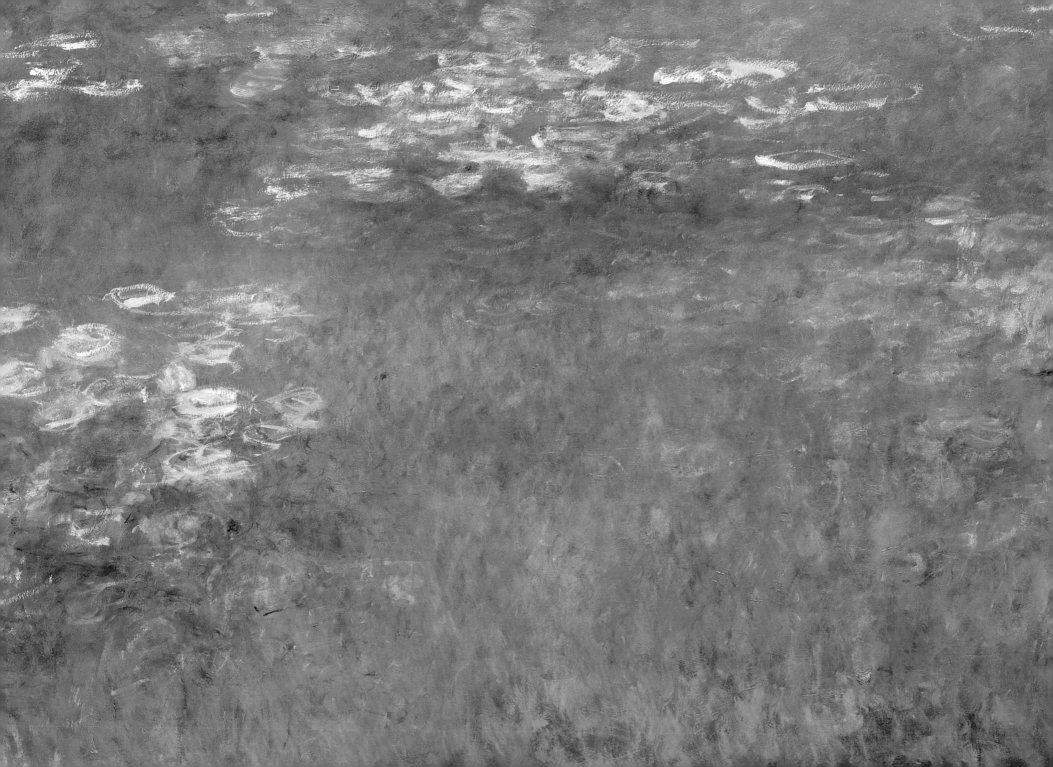

FIG. 1 (LEFT)
Cross-section from the upper left of *Water Lilies* (The Nelson-Atkins Museum of Art), original magnification 100x, visible light. The first layer of paint lies on top of the white ground layer. All subsequent illustrations are the Nelson-Atkins's *Water Lilies*, unless noted otherwise.

FIG. 2 (CENTER)
Cross-section from the center of the left edge of *Water Lilies*, original magnification 100x, visible light.

FIG. 3 (RIGHT)
Cross-section from the bottom right edge of *Water Lilies*, original magnification 160x, visible light.

be associated with a band of color, perhaps where the central band of greenish yellow overlaps the purple. The yellow color brings to mind Arsène Alexandre's 1920 description of the triptych as "molten gold,"[3] though it is impossible to determine which paint layers were visible at the time of his studio visit.

As the painting progressed, the background colors began to function like an underpainting, as Monet diffused the bands with additional paint. During this intermediate stage, the artist wrestled with the composition and made significant alterations. Many of these changes are apparent when we compare *Water Lilies* to the study and to contemporary photographs of the triptych (see Kelly, fig. 13). Further revisions by the artist are evident when the painting is examined with raking light and x-radiography.

Illuminating the painting's surface with raking light emphasizes a number of thickly painted lily pads and blooms that Monet subsequently covered.[4] Figure 4 shows the thick, swirling impasto of

an overpainted blossom. Monet's brush skimmed the upper layers of the bloom, adding a lavender that barely conceals the flower. He did the same with a bloom at the upper-left corner of the composition, as can be seen in the sequence of paint layers in figure 5. This cross-section shows extremely thin, intermittent layers of yellow, orange, and lavender lying on top of the white ground. These layers may relate to the preliminary outlines of the water lilies. Above these washes, we see the thick red paint of the flower that now lies below an upper layer of lavender.

In order to better illustrate Monet's compositional changes across the entire painting, we have created a diagram that notes the thick underlying paint strokes associated with reworked areas (fig. 6). The diagram conveys the magnitude of Monet's revisions, particularly changes he made to the canvas's lower center and upper right.

X-radiography also identified water lilies that are now covered by paint and no longer visible to the naked eye.[5] Monet's use of lead-white

FIG. 4

Upper-right quadrant
(4 ¼ x 5 ½ in.) of *Water Lilies*.

FIG. 5

Cross-section from the upper-
left corner of *Water Lilies*,
original magnification 40x,
visible light.

55

paint in the rendering of the pads and blooms makes them quite prom-
inent on an x-radiograph. Comparison of the upper-right quadrant of
the painting and its corresponding x-radiograph reveals five flowers
that Monet painted out entirely: four on the upper left and one on
the lower right (figs. 7–8). The high contrast of the x-radiograph also
draws attention to Monet's confident, energetic brushwork.

When the lower center of the final painting is compared to the
x-radiograph of the same area, we see a raft of water lilies that Monet
decided to eliminate (figs. 9–10). Many of the water-lily shapes and
stems first depicted in the study can be identified in the x-radiograph.
Their presence emphasizes the artist's close adherence to the study
when he first began painting. A photograph of the triptych in the

FIG. 6 (ABOVE)
Diagram of *Water Lilies* indicating the locations of thick underlying paint strokes associated with lily pads (horizontal lines and ovals) and blooms (dots).

FIG. 7 (ABOVE RIGHT)
Upper-right quadrant (13 ¾ x 15 ½ in.) of *Water Lilies*.

FIG. 8 (OPPOSITE)
X-radiograph corresponding to fig. 7.

artist's studio in 1921 (Kelly, fig. 13) confirms that Monet had already reworked the composition. A lily pad and bloom reproduced from the lower left of the study are evident in the x-radiograph of *Water Lilies*. These shapes were clearly covered by paint and thus are not visible in the photograph.

X-radiography records dense paint strokes from all stages of painting so that, in addition to water lilies that match the study, we find deviations and traces of other shapes that indicate further reworking. Although the exact sequence and date of the changes are unknown, it is clear that *Water Lilies*, and the triptych as a whole, evolved gradually rather than in a single intensive repainting session.

In addition to compositional changes, Monet's palette shifted from the early to late stages of execution. The cross-sections can be used to distinguish Monet's initial color choices from his late ones. In many cases, the cross-sections contain bright lower layers that are

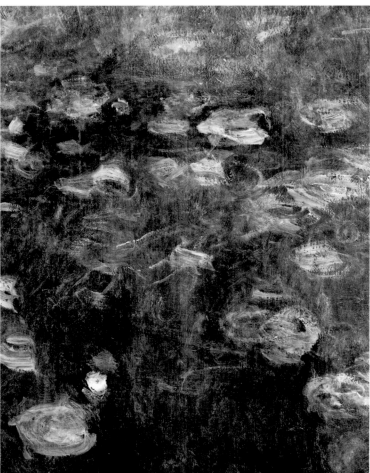

FIG. 9 (LEFT)
Lower center (35 x 42 in.) of *Water Lilies*.

FIG. 10 (RIGHT)
X-radiograph corresponding to fig. 9.

similar to the vivid hues of the study, particularly the green in figure 2, the red in figure 11, and the yellow in figure 1. While these early layers follow the colors of the study, they differ from the upper paint layers in the cross-section—pale blue, lavender, pink, and peach—that correspond to the pastel colors on the surface of the completed painting.

Although this technical study focuses on the right panel, *Water Lilies*, Monet painted the triptych's three components in unison. Therefore, the other panels most likely went through a similar process in terms of construction and shifts in color palette. X-radiographs of the St. Louis and Cleveland panels show extensive compositional

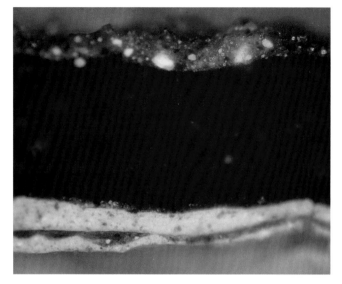

FIG. 11
Cross-section from the lower-left quadrant of *Water Lilies*, original magnification 80x, visible light.

FIG. 12 (TOP)
Center of bottom edge (26 x 53 ½ in.) of *Water Lilies* (Saint Louis Art Museum).

FIG. 13
X-radiograph corresponding to fig. 12.

reworking. The raft of water lilies below the paint surface in the St. Louis panel stand out clearly in the corresponding x-radiograph (compare figs. 12–13), as do the agapanthus plants of the Cleveland panel, both of which Monet painted over (compare figs. 14–15).

Beneath the lively brushwork and paint layers of *Water Lilies*, we see a very different starting point that is closely associated with the study. From this first stage of painting, Monet embarked on a compositional journey in which his decisions and reworking occurred directly on the canvas. Transformed in composition, brushwork, and color, the final painting bears little resemblance to its study and demonstrates the degree to which Claude Monet never ceased in his pursuit of the most elusive effects.

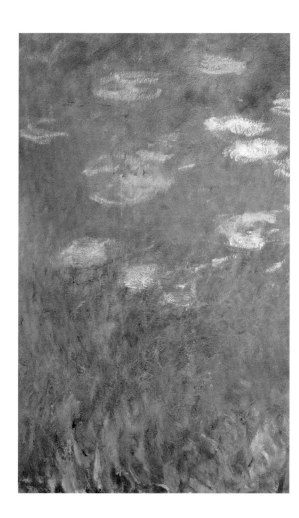

FIG. 14 (LEFT)

Lower left (58 ½ x 35 in.) of *Agapanthus* (The Cleveland Museum of Art).

FIG. 15 (RIGHT)

X-radiograph corresponding to fig. 14. Black lines mark the location of the agapanthus flowers. Monet rendered the blossoms with dabs of dense paint that appear white in the x-radiograph.

NOTES

1. The Nelson Atkins Museum of Art gratefully acknowledges the support of the Andrew W. Mellon Foundation Conservation Science Program for the technical analysis of *Water Lilies*.

2. A cross-section is a minute sample of the painting—roughly the size of a pinprick—that is carefully removed from an existing crack, paint loss, or a painting's outermost edge. The sample is embedded in resin and ground to expose the layered structure, from top to bottom. The cross-sections are then viewed with an ultraviolet/visible light microscope to study the individual layers.

3. Arsène Alexandre, "L'Épopée des Nymphéas." *Le Figaro*, Oct. 21, 1920.

4. During raking-light examination, a light source is placed parallel to the painting surface, creating highlights and shadows that emphasize the paint texture.

5. When a painting is examined with x-radiography, x-rays pass through the front of the painting and expose film placed behind the canvas. Pigments such as lead white that contain heavy metals block the x-rays from reaching the film and thereby create white areas on the x-radiograph.

SELECTED BIBLIOGRAPHY

Baillio, Joseph, ed. *Claude Monet (1840–1926): A Tribute to Daniel Wildenstein and Katia Granoff*. Exhibition catalogue. New York: Wildenstein Gallery, 2007. With essays by Richard R. Brettell, Charles F. Stuckey, Paul Hayes Tucker, and Eric Zafran.

Bocquillon, Marina Ferretti, ed. *Monet's Garden in Giverny: Inventing the Landscape*. Exhibition catalogue. Milan: 5 Continents Editions; Giverny: Musée des Impressionismes, 2009.

Claude Monet, 1840–1926. Exhibition catalogue. Paris: Réunion des Musées Nationaux, 2010.

Georgel, Pierre. *Monet, Le cycle des Nymphéas: Catalogue sommaire*. Exhibition catalogue. Paris: Réunion des Musées Nationaux, 1999.

Gerstein, Marc. *Impressionism. Selections from Five American Museums*. Exhibition catalogue. New York: Hudson Hills Press, 1989.

Gordon, Robert, and Andrew Forge. *Monet*. New York: Harry N. Abrams, 1983.

Hoog, Michel. *Musée de L'Orangerie: The Nymphéas of Claude Monet*. Paris: Réunion des Musées Nationaux, 2006.

House, John. *Monet: Nature into Art*. New Haven/London: Yale University Press, 1986.

Lemonedes, Heather, Lynn Federle Orr, and David Steel. *Monet in Normandy*. Exhibition catalogue. New York: Rizzoli, 2006. With essay by Richard R. Brettell.

Moffett, Charles S., and James N. Wood. *Monet's Years at Giverny: Beyond Impressionism*. Exhibition catalogue. New York: The Metropolitan Museum of Art, 1978.

Rey, Jean-Dominique, and Denis Rouart. *Monet Water Lilies: The Complete Series*. Paris: Flammarion, 2008.

Spate, Virginia. *Claude Monet: The Color of Time*. London: Thames and Hudson, 1992.

Stuckey, Charles F., ed. *Monet: A Retrospective*. New York: Hugh Lauter Levin Associates, 1985.

Stuckey, Charles F., et al. *Monet, L'oeil impressioniste*. Exhibition catalogue. Paris: Éditions Hazan/Musée Marmottan Monet, 2008.

Temkin, Ann, and Nora Lawrence. *Claude Monet: Water Lilies*. Exhibition catalogue. New York: Distributed Art Publishers/The Museum of Modern Art, 2009.

Tucker, Paul Hayes. *Claude Monet: Life and Work*. New Haven/London: Yale University Press, 1995.

Tucker, Paul Hayes. *Claude Monet: Late Work*. Exhibition catalogue. New York: Gagosian Gallery, 2010.

Tucker, Paul Hayes, with George T. M. Shackelford and MaryAnne Stevens. *Monet in the 20th Century*. Exhibition catalogue. New Haven/London: Yale University Press, 1998. With essays by John House, Romy Golan, and Michael Leja.

Wildenstein, Daniel. *Claude Monet: Biographie et catalogue raisonné*, 4 volumes. Lausanne/Paris: Bibliothèque des Arts, 1974–91.

Wildenstein, Daniel. *Monet, or the Triumph of Impressionism, Catalogue Raisonné*, 4 volumes. Cologne: Taschen, 1996.

© Archives Nationales, Paris: Kelly essay figs. 22–23, 31
Photography © The Art Institute of Chicago: Kelly essay fig. 37
© Mme Jacqueline Aubart: Kelly essay figs. 9–10
© 2010, reproduced with the permission of The Barnes Foundation: Kelly essay
 fig. 20
Johanna Bernstein: Schafer and Bernstein essay figs. 1–3, 5, 11
Bibliothèque Nationale de France: Kelly essay fig. 7
The Bridgeman Art Library: Kelly essay figs. 5–6, 15, 17
The Cleveland Museum of Art: Kelly essay figs. 1 and 29 (left); Schafer and
 Bernstein essay, fig. 14
© Country Life 74, 1916 (October 7, 1933): Kelly essay fig. 3
© Durand-Ruel & Cie.: Kelly essay figs. 8, 11–12
Galerie Bernheim-Jeune, Paris. From personal archives of Robert Gordon: Kelly
 essay fig. 13
© Getty Images: Kelly essay fig. 19
Glue + Paper Workshop, Chicago: Kelly essay figs. 25, 33 (see also Mary Schafer)
Paul Haner: Schafer and Bernstein essay fig. 13
© Simon Kelly: Kelly essay fig. 35, figs. pp. 63–64
Minneapolis Institute of Arts: Kelly essay fig. 40
Courtesy Missouri Botanical Garden PlantFinder, Thomas Pope: Kelly essay fig. 14
© Musée Rodin, photo by Jérôme Manoukian: Kelly essay fig. 24
The Nelson-Atkins Museum of Art, Kansas City, Missouri, Louis Meluso, Imaging
 Services Department: Kelly essay, figs. 1 and 29 (right); Schafer and Bernstein
 essay, figs. 7, 9, 10, 13, 15. The Nelson-Atkins Museum of Art Archives: Simon
 essay, fig. 42.
The Philadelphia Museum of Art/Art Resource, NY: Kelly essay fig. 4
© Collection Philippe Piguet, Paris: Kelly essay fig. 18
Réunion des Musées Nationaux/Art Resource, NY: Kelly essay figs. 2, 26–28, 34
Joe Rogers: Schafer and Bernstein essay figs. 8, 10
Rogier-Viollet Agency: Kelly essay fig. 43
Saint Louis Art Museum: Kelly essay figs. 1 and 29 (center), 30, 38; Schafer and
 Bernstein essay, fig. 12. Saint Louis Art Museum Archives: Kelly essay fig. 41.
Mary Schafer: Schafer and Bernstein essay figs. 4, 6 (with Glue+ Paper Workshop),
 8, 10
Photo by Jean Paul Torno: Kelly essay figs. 32, 36, 39
© Courtney Traub: Kelly essay fig. 21
Dean Yoder: Schafer and Bernstein essay fig. 15

SIMON KELLY is Curator of Modern and Contemporary Art at the
Saint Louis Art Museum. His research interests focus on nineteenth- and
early-twentieth century French art. His many publications include
Untamed: The Art of Antoine-Louis Barye (2006) and essays in the exhibi-
tion catalogues *Renoir Landscapes, 1865–1883* (2007), *In the Forest of
Fontainebleau: Painters and Photographers from Corot to Monet* (2008),
and *Manet, The Man who Invented Modern Art* (2011).

MARY SCHAFER is associate painting conservator at the Nelson-Atkins
Museum of Art, Kansas City, Missouri. She received her MA and CAS in
art conservation from Buffalo State College, State University of New York.
She is currently writing technical notes for the forthcoming French paint-
ings catalogue at the Nelson-Atkins.

DR. JOHANNA BERNSTEIN is a materials scientist in the Institute for
Advance Materials, Devices and Nanotechnology at Rutgers—The State
University of New Jersey. She has been working as a science adviser to the
Nelson-Atkins Museum of Art under a grant from the Mellon Foundation.

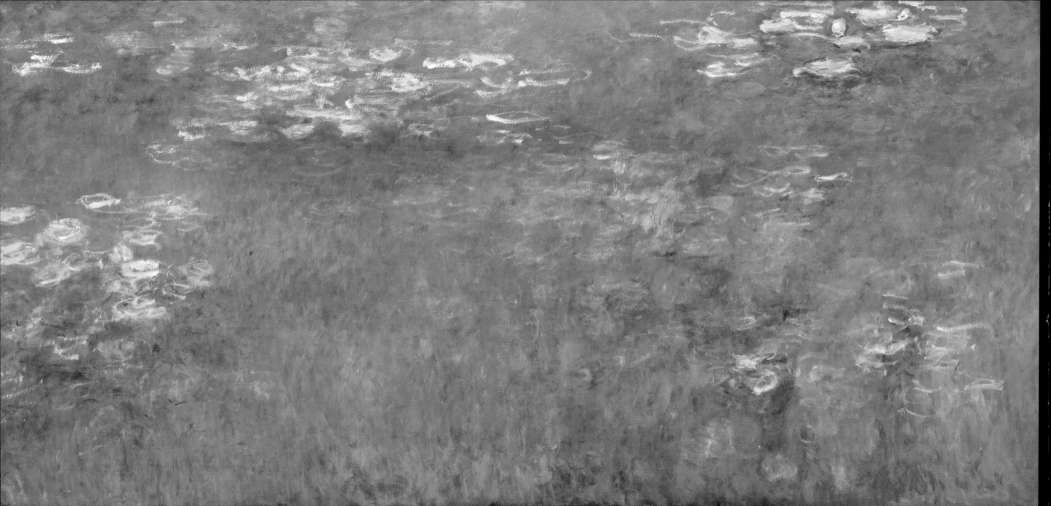